UNDERSTANDING COMICS-BASED RESEARCH

UNDERSTANDING COMICS-BASED RESEARCH

A Practical Guide for Social Scientists

BY

VERONICA MORETTI
University of Bologna, Italy

emerald PUBLISHING

United Kingdom – North America – Japan – India
Malaysia – China

Emerald Publishing Limited
Emerald Publishing, Floor 5, Northspring, 21-23 Wellington Street, Leeds LS1 4DL.

First edition 2023

Reprints and permissions service
Contact: www.copyright.com

British Library Cataloguing in Publication Data
A catalogue record for this book is available from the British Library

ISBN: 978-1-83753-463-0 (Print)
ISBN: 978-1-83753-462-3 (Online)
ISBN: 978-1-83753-464-7 (Epub)

Printed and bound by CPI Group (UK) Ltd, Croydon, CR0 4YY

INVESTOR IN PEOPLE

This book is not dedicated to a specific person. I'd like to think that this manuscript is the fruit of that part of academia that still believes in color, passion and gratitude. To those parts, I hereby dedicate my book.

CONTENTS

LIST OF FIGURES

ABOUT THE AUTHOR

Veronica Moretti is an Assistant Professor at the University of Bologna. Her main research interests lie in the field of creative methods within social research and on the intersections between technology and human activities, with specific emphasis on the medical sociology. She is currently using several innovative teaching strategies applied to "health education" activism, ranging from the use of graphic novels to the use of audio-diary recording with health-care professionals to develop their social and relational skills. Also, she is one of the founders of the *Graphic Medicine Italia* association.

ACKNOWLEDGMENTS

So, to start off, that's myself (Fig. I) enjoying these months of intense writing, studying, and drawing.

Fig. I. Myself.

And, as is expected in most publications, I thank the person who supported me the most (Fig. II).

Fig. II. The Person Who Supported Me the Most.

And these are the hypothetical readers (Fig. III) I want to thank in advance for joining me on this venture!

Fig. III. Hypothetical Readers.

INTRODUCTION

This book owes much to many figures, people, and experiences, starting with its title. The more experienced will have immediately caught the similarity to Scott McCloud's monumental *Understanding Comics*. The idea was precisely to start from there, from understanding comics in its holistic dimension. McCloud's purpose, however, is not to provide a precise definition of comics art; instead, the "attempt" (McCloud himself calls it) is to "close every semantic loophole" and see the history of comics from a new angle. However, the perspective that moves this book is the contribution of comics within social research, both as a new epistemological and methodological form.

For a long time, considered a minor genre, comics and graphic novel have recently been accepted and qualified as the "Ninth Art," a term coined by French critic Claude Beylie who took up and expanded on Ricciotto Canudo's "seven arts".[1] A peculiar art form capable of mixing writing and drawing (and often as the result of the work of several artists), comics has established itself on the media and scientific scene, thanks to its most illustrious representatives who have traced its specificity and complexity of a medium capable of overcoming generational barriers and proposing new social and literal genres.

The perceptual mechanisms of comic books (images) combined with their mechanics (words) have been incorporated within so-called Arts-Informed Research (AIR), a research approach that has grown exponentially in the last decade in qualitative studies internationally. AIR procedures and practices are substantiated by approaches that combine the rigor of science with the creativity of art (Cole & Knowles, 2001) during the research process, including conceptualization, data collection, analysis, and dissemination (Kara, 2015; Knowles & Cole, 2008; Leavy, 2018).

In this book, therefore, I focus on the contribution that comic books are able to make to social research as part of a construct that can be called "Graphic social science" (Kuipers & Ghedini, 2021; Nalu, 2011; Short, Randolph-Seng, & McKenny, 2013). Comics and graphic novels are recognized as part of visual methods (Sassatelli, 2021) and used in community-based participatory

research because the juxtaposition of text and images offers multiple oppor-
tunities for research and communication (Barberis & Grüning, 2021; Leavy,
2018). In addition to their empirical potential, comics can be used within
new theoretical frameworks such as postmodernism, poststructuralism, and
postcolonialism studies and applied to generate new guiding principles, such
as participation or co-production (Masciopinto, 2019).

Within the first chapter, I propose a vocabulary of comics, presenting key
terms and critical concepts used specifically in current comic studies. First,
the "Shakespearian limbo" between what is or is not a comic book is a very
ambiguous one, with scholars disagreeing on the definition of comics. Giv-
en the complex nature of the medium and its continual transformation, it is
impossible to rely on a single definition of comics. For that reason, in the first
chapter, I explore various labels and formal elements that are far from mere
picture books. In addition to the interdependent relationship between images
and words, I briefly review the history of comics as a profound and controver-
sial trajectory. Comics have undergone nuanced evolution in both content and
style, consistently playing a crucial role in understanding and communicating
political and social phenomena. However, artists from marginalized groups
(women, African-Americans, LGBTQ2S+) have remained behind the scenes,
struggling to establish themselves until a few decades ago.

In the second chapter, I examine the convergence of comics and the social
sciences. Comics are now central pieces of material culture, created almost
everywhere in varying formats.

Thanks to the intersection of the most diverse cultures and ideas, this medi-
um of visual expression has undergone significant development over the past
century. However, this form of visual communication is far from new.

In 1944, the *American Journal of Education* published a special issue
devoted to comics. Edited by Harvey Warren Zorbaugh, all contributions in
the special issue emphasized the potential of comics in education, specifically
for children with learning disabilities. Academic attention to comics increased
dramatically in the 1990s, continuing into the first half of the 2000s. Today,
the use of comics and graphic novels in research is increasingly common in
the social sciences. As a central element in visual studies and contiguous in
education research, comics have also become the subject of sociological and
anthropological research. As such, it is possible to consider a defined estab-
lishment of Graphic Social Sciences a "comics-based research" (Nakazawa,
2005; Nalu, 2011; Short et al., 2013).

Chapter three takes a pragmatic line, exploring the vast potential of using
comics in research, including multimodal and sequential data collection meth-
ods, analysis, and dissemination. This chapter will propose practical steps for

implementing a comics-based project. As for the methodological point of view, comics-based research offers multifaceted research and communication opportunities by referring to visual and verbal literacy. This prospect ensures responsiveness to the natural flow of events and experiences and serendipity and can foster the reflexivity inherent in qualitative research.

As a first step, I will conceptualize how to plan research using comics. Comics are most valuable when integrated into the research process from the beginning with initial research planning. Comics can explore the potential of narrative inquiry (Connelly & Clandinin, 1990) by paying attention to the narrative nature of the participants. For researchers, comics can be made as a form of field notes, capturing visual and non-verbal communication data in the field. This advantage is particularly visible in the ethnographic approach, where comics can be used to explore emerging ideas, just as a researcher might create a mind map or write a theoretical memo.

Second, comic strips can be used in the data collection process, presenting a multitude of possibilities. For Madrid-Manrique (2014), comics allow for re-presentation and retelling of difficult experiences such as loss and vulnerability. In addition, information, instructions, and questions can be communicated with words and pictures. Following McNicol, (2019), the uses of comics as part of data collection include:

- documents in comic form (information sheet, debrief sheet, questionnaire);

- elicitation (interview based on the comic strip drawn by the participant);

- sequencing of events;

- completion of comics (adding text to pictures or suggesting ways in which a sequence might continue);

- Multiple readings of a given comic strip (discussion of different interpretations).

Third, as Patricia Leavy (2018) stated, comics can be used to transcribe interviews, complete with body language and facial expressions. In addition, it is possible to create a comic strip based on the interview with a participant, especially if the researcher has the opportunity to work with a comic strip creator. Of course, technical skill in writing and drawing is not a prerequisite for creating comics, but working with a professional has an impact on the realization of the project.

Fourth, in analyzing the visual material, it is crucial to remember that comics are anything but static. With sequences of panels, flipping pages, and

different reading options (asynchronous, synchronous, paying attention first to images and then to words and vice versa), comics are dynamic, fluid, and in constant negotiation with the subject matter.

Concerning the ethical dimension, these methods allow for a voice to be given to many types of participants, especially to vulnerable groups (disabled, migrants, children) usually not easily engaged by more traditional qualitative methods. However, participation could have several emotional, psychological, and privacy-related implications. For this reason, ethical considerations must permeate the entire research process, especially in biomedical research.

Using comic books as a research method can present several practical challenges. First, comic book analysis requires a substantial degree of reader participation. In addition, this technique requires a great deal from both researchers and participants. The use of comics in vulnerable situations could recall traumatic memories and lead to mental health problems.

In the last chapter, I examine comic books' social and cultural impact and effectiveness in communicating messages and reaching a broad audience. Therefore, I will discuss the "social genre" of comic books.

Starting with four case studies focusing on specific topics (health, migrants, environment, and gender), I will try to distinguish the contribution comics research methods can make to qualitative research and consider the challenges they can bring from a sociological perspective.

The first example is Graphic Medicine, or the use of comics as a medium to analyze and communicate health issues, around which a community of academics, health professionals, authors, and artists is growing internationally. The visual language of comics can make the information not only more accessible but also help overcome language barriers (Farinella & Mbakile-Mahlanza, 2020). It should therefore come as no surprise that comic books have begun to be used for health education and communication, despite the significant cultural differences in visual vocabulary and must be carefully considered when creating educational materials (Cohn, 2016). Public health educators have been using comics to communicate information to people for many years to convey information about skin cancer (Putnam & Yanagisako, 1982), HIV/AIDS (Gillies, Stork, & Bretman, 1990), body donation (Irwin, Roughley, & Smith, 2020), Parkinson's disease (Myers et al., 2019), and medical education (Green & Myers, 2010).

As a second example, I will describe the graphic narrative of migration. Migration comics have evolved through various languages, cultures, and eras, reflecting diverse socio-political perspectives. Simultaneously, comics not only portray the political and social aspects of migration but also serve as

instruments to advocate for either acceptance or rejection of migrants. Simple techniques can be used in complex ways: the construction of space in a sequence can be relevant to present the traumatic experience of the migration journey visually; colors or lack thereof can represent the feelings (fear, hope, despair) of migrants once in the new place; thought bubbles can express painful memories; speech bubbles can show the frustration of not knowing the local language. More comics could be key to addressing some of the mental health challenges of migration. Moreover, as Kate Evan explains in her book *Threads from the Refugee Crisis*, comics can express the stories of "people who don't matter."

A third case is the potential of "comics-based research" to offer readers a new vision of climate change that can reinforce thoughts and actions about the phenomenon. The realm of comics is intimately familiar with matters concerning pollution, climate change, and human influence on the planet. These subjects are frequently depicted and conveyed in distinctive and unconventional ways, balancing between popularization and an intention to evoke emotions.

Finally, the last social genre concerns women and gender studies. As presented by Aldama (2021) in her book *The Routledge Companion to Gender and Sexuality in Comic Book Studies*, a diverse range of international and interdisciplinary scholars look closely at how gender and sexuality have been essential in the evolution of comics. In particular, the authors focus on how gender and sexuality in comics require reformulating and revising the history of comics and raising public awareness of this issue.

NOTE

1. According to Canudo, cinema represented the seventh art form after poetry, painting, sculpture, music, dance, and architecture. His idea was to emphasize the artistic value of cinema by recognizing it as an art in its own right.

REFERENCES

Aldama, F. L. (2021). *The Routledge companion to gender and sexuality in comic book studies*. London: Routledge.

Barberis, E., & Grüning, B. (2021). Doing social sciences via comics and graphic novels. *An Introduction, in «Sociologica»*, 15(1), 125–142.

Cohn, N. (2016). A multimodal parallel architecture: A cognitive framework for multimodal interactions. *Cognition: International Journal of Cognitive Science, 146*(January), 304–323.

Cole, A. L., & Knowles, J. G. (2001). *Lives in context: The art of life history research*. Lanham, NJ: AltaMira Press.

Connelly, F. M., & Clandinin, D. J. (1990). Stories of experience and narrative inquiry. *Educational Researcher, 19*(5), 2–14.

Eisner, W. (1996). *Graphic storytelling and visual narrative*. New York: Poorhouse Press.

Farinella, M., & Mbakile-Mahlanza, L. (2020, January). Making the brain accessible with comics. *World Neurosurgery, 133*, 426–430. doi: 10.1016/j.wneu.2019.10.168. PMID: 31881560

Gillies, P. A., Stork, A., & Bretman, M. (1990). Streetwize UK: A controlled trial of an AIDS education comic. *Health Education Research, 5*(1), 27–33.

Green, M. J., & Myers, K. R. (2010). "Graphic medicine: Use of comics in medical education and patient care." *BMJ: British Medical Journal, 340*(7746) (March), 574–577.

Irwin, J., Roughley, M., & Smith, K. (2020). 'To donate or not to donate? that is the question!': An organ and body donation comic. *Journal of Visual Communication in Medicine, 43*, 103–118.

Kara, H. (2015). *Creative research methods in the social sciences: A practical guide*. Bristol: Policy Press.

Knowles, J. G., & Cole, A. L. (2008). *Handbook of the arts in qualitative research: Perspectives, methodologies, examples, and issues*. Los Angeles, CA: Sage Publications.

Kuipers, G., & Ghedini, F. (2021). Beauty: Triggering the sociological imagination with a webcomic. *Sociologica, 15*(1), 143–162.

Leavy, P. (2018). *Handbook of arts-based research*. New York: Guilford Press.

Madrid-Manrique, M. (2014). *A comic based research methodology*. Dissertation Thesis. Retrieved from https://artography.edcp.educ.ubc.ca/?p=1154

Masciopinto, M. (2019). "Antropologia, ricerca sul campo e comunicazione visiva: il fumetto come strumento e linguaggio della scrittura etnografica". *Cahiers di Scienze Sociali, 11*, 126–136.

McCloud, S. (1994). *Understanding comics: The invisible art.* New York: Harper Perennial.

McNicol, S. (2019). Using participant-created comics as a research method. *Qualitative Research Journal, 19*(3), 236–247.

Myers, K. R., George, D. R., Huang, X., Goldenberg, M. D. F., Van Scoy, L. J., Lehman, E., & Green, M. J. (2019). Use of a graphic memoir to enhance clinicians' understanding of and empathy for patients with Parkinson Disease. *Perm J.,* 24:19.060.

Nakazawa, J. (2005). Development of manga (comic book) literacy in children. In D. Shwalb, J. Nakazawa, & B. Shwalb (Eds.), *Applied developmental psychology: Theory, practice, and research from Japan.* Greenwich: Information Age Publishing.

Nalu, A. (2011). Comics as a cognitive training medium for expert decision making. *Proceedings of the Human Factors and Ergonomics Society Annual Meeting, 55,* 2123–2127.

Putnam, G. L., & Yanagisako, K. L. (1982). Skin cancer comic book: Evaluation of a public educational vehicle. *Cancer Detection and Prevention, 5*(3), 349–356. PMID: 7151069.

Sassatelli, M. (2021). Show and tell. *Sociologica, 15*(1), 311–319.

Short, J., Randolph-Seng, B., & McKenny, A. (2013). Graphic presentation: An empirical examination of the graphic novel approach to communicate business concepts. *Business and Professional Communication Quarterly, 76,* 273–303.

Zorbaugh, H. W. (1944). The comics. There they stand! *The Journal of Educational Sociology, 18*(4), 196–203.

1

THE COMICS JARGON

1. WHAT *IS* COMICS? PROVIDING VOCABULARY AND EXAMPLES OF COMICS TERMINOLOGY

In this first chapter, I will describe key terms and critical concepts used in specific ways in current comic studies. First, the boundary of what is or is not a comics is a very ambiguous line. Scholars disagree on the definition of comics; with some describing comics as the printed arrangement of art and balloons in sequence (Eisner, 1996); and others referring to comics as juxtaposed pictorial and other images in deliberate sequence, intended to convey information and to produce an esthetic response in the viewer (McCloud, 1994). Eddie Campbell, one of the key players in the rise and international spread of the Anglophone literary comics and graphic novel, contrasted the word comics by offering the term graphic storytelling as the art of using pictures in sequence and its attendant language of forms and techniques, refined over many centuries.

I propose to the reader an array of inventive analyses of terms central to the study of comics and sequential art that are traditionally siloed in distinct lexicons. The entire vocabulary of comics is much more than images and words on the page; it also includes that which is in the reader's mind (McCloud, 1994).

Nowadays, comics should be understood as one of the pivotal centers of contemporary storytelling, one of the sites of rewriting the relationships and balances between media and the arts (Benvenuti, 2019). Thanks to the cross-pollination of varied cultures and ideas, this form of visual communication has experienced significant development in the last century. Comics today are a central piece of culture, being created almost everywhere and in different formats. However, scholars disagree on the definition of it, and comics

terminology poses serious challenges to the field of comic studies is old news for any of us who write about comics.

This first section aims to understand the specific dictionary of comic studies. In approaching comics-based research, the researcher must first begin by understanding the complex language of comics, its nuances, and basic vocabulary. In this book, and following other authors (Arffman, 2019; Chute, 2017), I will use comics as a singular noun,[1] sometimes adopted to refer to individual comic periodicals, known in North America as "comic books." As Hillary Chute (2017) points out to us in her book, *Why Comics?*, in the Anglo-Saxon language, the word comics refers in its meaning to something funny that generates laughter. However, not all comics set out to do this; as we will see in Chapter 4, some genres have an educational and informative rather than a playful purpose. To that end, exploring how other languages formulate their definitions of comics is interesting. For example, in Italy, the form used is *fumetto*, which means "little puffs of smoke" and refers to speech balloons (Chute, 2008). Additionally, in this particular form of comics, photographs, not drawings, are the principal visual component (Baetens & Mélois, 2018; Castaldi, 2004). Another interesting example comes from the Franco-Belgian language, where the word comics is *bande dessinée*, which literally means drawn strip, referring to the image of a single-tier comic strip (Chavanne, 2010; Flinn, 2013; Grove, 2010; Menu, 2011). In Spanish, comics is translated with the term *historieta*. In all these definitions, comics describes a formal element of their production (unlike the English iteration).

Across time and space, comics as a medium has developed its own specialized terminology. Several attempts have been made to formalize a standard glossary by authors such as Nancy Pedri with *A Concise Dictionary of Comics* or Mort Walker's *The Lexicon of Comicana* ([1980] 2000). Kevin J. Taylor also formed an explanatory comics vocabulary resource with their specialized dictionary of comic sound effects, *KA-BOOM! A Dictionary of Comic Book Words, Symbols & Onomatopoeia* (2007). Easily accessible online comics dictionary and reference resources include Andrei Molotiu's "List of Terms for Comics Studies" (2013), Trevor Van As's "Glossary of Comic Book Terms" (2013), Heritage Auctions's "Glossary of Comic Terms" (2004), and Stephanie Cooke's "A Glossary of Comic Book Terminology" (2019). Trying to provide a substantive definition of comics, and opening with one of the most famous authors, Eisner (1996) described comics as the printed arrangement of art and balloons in sequence, while McCloud starts by trying to define what the word "comics" means. Starting from an earlier definition put forth by Eisner, McCloud twists and modifies it over a series of pages, winding up with their own (1994, p. 9). Comics refers to "juxtaposed pictorial and other images in

a deliberate sequence, intended to convey information and/or produce an aesthetic response in the viewer." Both Eisner and McCloud, like others, starting from the idea of comics understood as sequential art and thus bringing the temporal factor to the fore, do nothing more than analyze comics in the same way as a language. Comparing comics to literature, in particular, and writing in general, is a short leap from here. However, we find other definitions that focus on different aspects. Historian, critic, and cartoonist, Robert C. Harvey speaks of comics as "pictorial narratives or expositions in which the words (often inscribed in the drawing area inside talking clouds) usually contribute to the meaning of the images and vice versa" (2010, p. 1).

Another formal definition would be to state that comics are "the phenomenon of juxtaposing images in a sequence" (Duncan & Smith, 2009, p. 3) or a narrative medium in which stories are told by combining images in a deliberate, meaningful way (Gravett, 2013; Groensteen, 2007; Meskin & Cook, 2012; Pizzino, 2016).

The common trait of all the explanations is that comics are not illustrated books. They have a special kind of literacy all their own.

In their *Power of Comics* (2009), Randy Duncan and Matthew J. Smith argue that the following formal constraints characterize the comic book: (a) spatial limitations, meaning the number of pages and the page size, reproduction technologies, so paper quality; (b) unrealistic images since comics are two-dimensional and lack the photo-realistic qualities of some other forms of visual storytelling media; (c) limited capacity to control the reader (readers can view panels and pages in any order and for any duration); (d) the page as a unit of composition (allows some control over the reader); (e) the conception of images as selected moments; (f) interdependence of words and pictures; (g) artistic skill (what the cartoonist can achieve); (h) the serial esthetic (most mainstream comic books are published as episodes in an ongoing saga).

More recently, comics have also been subjected to broader theoretical frameworks of visual language and meaning-making – semiotic, linguistic, or cognitive – in ways that may downgrade the question of comics as a self-respecting medium, literature, or art form.

Indeed, for a long time, the question asked was where to place the particular narrative of comics and in what form of literature or visual art. Mikkonen (2017) tries to overcome these limitations by positing an accurate analysis of *The narratology of comics art*. According to the author, treating comics as narrative allows us to avoid the word–image dichotomy. Whereas "a comic" may have persistent associations with humor, cartoon-style artwork and narrative, and weekly print publication schedules, this is but part of the comics medium.

From the point of view of the object, comics is part of the many forms that icon texts are taking in contemporary times, testifying to a permeability between languages and artistic forms, which is nonetheless growing to the point that it can be described in terms of a constant "semiotic interchange" (Benvenuti, 2019).

Already in the 1964s, Marshall McLuhan began to publish a series of dense books about the ways mass media affect our lives. He defined "modern" comic strips and comic books as a tool

> provide very little data about any particular moment in time, or aspect in space, of an object. The viewer, or reader, is compelled to participate in completing and interpreting the few hints provided by the bounding lines. (p. 161)

These are qualities of what McLuhan termed "cool" media, creations that force us to fill in the blanks. He defined comics as a cool medium for two reasons: they are low definition (cartoony) and highly participatory (amplification through simplification and the closure of the gutter). They contrast with "hot" media like film, which make the viewer "a passive consumer of actions."

On reading comics, a novel narrative form is realized that is distinct from other forms (literature, poetry, photos). So, what make comics differ from other visual narratives? It tells stories by verbal means and by showing images, through their visual and spatial form, through their many combined visual–verbal signs and conventions, and through the interaction of these elements (Mikkonen, 2017). Thus, the relationships between literature and visual forms of representation are manifold. The communication of a story is, surely, not the only thing that pictures do in comics or what comics do, but it can also be a focus of its own. McCloud (1994) was used to frame the combination of words and images as "inter-dependent," meaning that words and pictures/images convey different meanings separately but in combination convey a meaning that neither has without the other. As stated by McNicol (2017), the interdependence of words and pictures makes comics an inherently multimodal medium: the communicative weight in comics is shared across both text and image. This multimodality differs from illustrated books in which the story stands alone (augmented by illustrations).

Additionally, the use of sequence in establishing a reading order, as seen in a series of comic panels, typically box-like frames used to present a chronology of events (McNicol, 2017). Comics exists in the realm of ideas, the transition from one panel to the next flows "seamlessly," but realistic drawings are seen more as a series of "still pictures." McCloud (1994) believes that when

reading comics, the spectator/reader perceives time spatially as she moves across the page from panel to panel. These panels act as a design tool for the reader to be able to distinguish varying moments in time.

What makes the comic book narrative so special is the active role played by the reader who does not act as a mere spectator of already set events but on the contrary intervenes in the plot itself by going on to shape the graphic sequences. In reading comic books, diegesis often implicates a narrator commenting on the story. While narrators usually share the common goal of giving readers inside information about the comic's story, they go about this in unique and different ways. McCloud talks about *closure*, the mental construction of a continuous, unified story through reading. In other words, it represents the reading process of connecting two or more structurally separate but juxtaposed panels into a meaningful whole (Gavaler & Beavers, 2020; McCloud, 1994; Saraceni, 2016). The comic book reader is helping create the meaning. The reader performs closure by using background knowledge and an understanding of panel relations to combine panels mentally into events. One of the most famous examples (Fig. 1.1) is a first panel where a man is about to be killed by an axe. The next panel is saying "EEYAA!!" and the reader might decide what is happening between the two panels. Did the man die? Is he crying out in pain? McCloud says, "To kill a man between the panels is to condemn him to a thousand deaths."

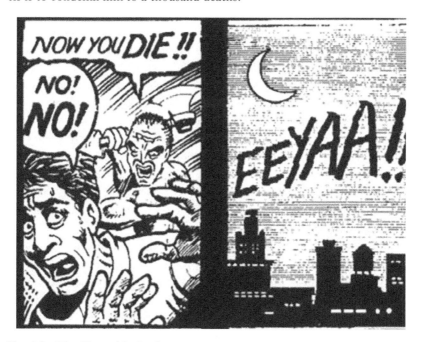

Fig. 1.1. The Man with the Axe.

The comics background is also far from being static. Sometimes all aspects of a comics production down to the editing, publishing, and distribution are done by a single person. In this case, cartoonists become the choreographer, the director, the screenwriter, the hairdresser, and even the costume designer of their characters.

At the other terminal, the work behind the comics creation is sometimes divided up into different specialties. It becomes an assemblage of roles, which can include, among other, these figures: the cartoonist, the artist, who handles the visuals; editors.

Taking Lisa Gitelman's definition (2006) of a *medium*, comic acts as social and cultural practices, normative rules, and default conditions that gather and adhere around shared protocols. Comics are based around a system of communication and information that is defined by a set of associated social practices, such as conventions of reading, genres, the publication format, and channels of distribution. In this regard, comics is a multimodal, medium that can make a unique contribution to the study of the relation between narrative and medium.

2. A SHORT HISTORY OF COMICS IN POPULAR CULTURE

Comics is often considered a weak expressive form and intellectual field in terms of its capacity for cultural impact, especially among adults. Less obvious are the reasons for this (Smolderen, 2014). It may be because of the absence of a crucial character – comics has not had its own Leonardo Da Vinci or its own Albert Einstein – it may be because for a long time some historical and theoretical questions have remained unexplored. However, only recently some attempts have been made to overcome the fragility of this medium in order to build a richer and more solid ground of knowledge. The origins of comics are rather far to trace. Intending as early as antiquity we can find visual narratives through the picture narratives produced by graffiti throughout the ancient Near East – in Egypt, the Sinai Peninsula, Asia Minor, the Levant, Mesopotamia, and Arabia. However, the birth of the comic strip has long been told according to definite strands.

One of the works that has attempted to compensate for the frailties around the historical and theoretical dimensions is the effort of Thierry Smolderen (2014), which addresses the history of comics by focusing particularly on the lesser-known, more archaeological history of the early days when this medium began to take hold. In particular, the choice of this reconnaissance begins with the rediscovery of the English painter William Hogart, considered one

of the founders of a satire that led all the way to the modern comic book and was described as the grandfather of the political cartoon. Hogart, according to Smolderen, is the artist who brought the art of printmaking into modernity by combining, in a disenchanted manner, the earlier tradition of narrative construction by images with the humorous literature that emerged in England at that time.

Beginning in the nineteenth century, Hogart's images started to inspire many artists and the first cartoons containing short texts, moreover handwritten, and printed on posters or in magazines began to appear. Among this, the chaotic pages of Yellow Kid intentionally recall the tradition inaugurated by Hogart. The Yellow Kid's first official appearance was on May 5, 1895, when, an anonymous bald, floppy-eared boy dressed in an oversized smock, made his appearance among the many characters who populated the plates of the Hogan's Alley series, conceived and drawn by Richard Felton Outcault and hosted in the pages of Joseph Pulitzer's Sunday supplement of the *New York World* newspaper. Taking his name precisely from the color of his smock (at least in the color version), The Yellow Kid, in first his entrance is almost always limited to appearing in the corner of the rich plates illustrated by Outcault. Commenting on the political and cultural events of the time, The Yellow Kid communicated through placards and, above all, pointed and often ungrammatical writing (to emphasize the ignorance of the various characters targeted), often appearing imprinted on his smock. Outcault will introduce into the series those elements (balloons first and foremost) that will help build the structure of modern international comics. The growing success of the Yellow Kid soon led to the coining of the term "yellow journalism" to refer to that press which, like Outcault's yellow brat, makes sensationalism its calling card.

Coupled with these, new publishers begin to take an interest in the communicative power of this character.

In particular, William Randolph Hearst, publisher of the *New York Journal* and Pulitzer's rival, did everything in his power to grab Outcault exclusively, eventually succeeding. From that moment, comic strips had been introduced in the sensational newspaper press to drive circulation – many comic strips were meant to appeal to children and to immigrant readers of newspapers – an explicit goal (Chute, 2011).

The publication that set the format for comic books as we know them conventionally was the 1934s *Famous Funnies*, which represents what Popular culture historians consider the first true American comic book. Following 1929s influential pioneer, *The Funnies*, which featured originally drawn strips and appeared from Dell on newsstands on tabloid-size newsprint, the 36-page

Famous Funnies: A Carnival of Comics was distributed through the Wool-worth's department store chain. A few years later, specifically in 1938, the so-called Golden Age of comics was inaugurated by a timeless and still relevant character: Superman. Created by Jerry Siegel and Joe Shuster, Superman is perhaps the most distinguishable comic book character to this day.

The success of Superman propagated a series of spin-offs and created a whole new genre of characters with secret identities, superhuman powers, and colorful outfits – the superhero. Batman and Robin, Wonder Woman, Plastic Man, Green Lantern, and Flash were among those who followed. The sales of comic books increased markedly during World War II. They were low-priced, light, and had inspirational, patriotic stories of good triumphing over evil. The tales very much reflected the events and values of the time. Pro-American characters were popular, particularly Captain America, a superhero whose whole construction was based on aiding the country's war effort. It was the era when comics were at their best regarding the growth and success of the comics industry. Before this era, most comics were just little strips in other books. It was not until the Golden Age that we saw the rise of actual comic books.

The comic book, however – at least in its first few decades – was tightly associated with youth culture. For this reason, the

> Golden Age ended in 1954, after psychiatrist Fredric Wertham's best-selling study Seduction of the Innocent, which aimed to establish a link between comic-book readership and juvenile delinquency, brought the comic-book industry to a halt. (Chute, 2017, p. 12)

Wertham was so persuaded that he made several publications between 1948 and 1957 stating that children should in no way be exposed to comic books. Specifically, the argument brought to the scientific community (and beyond) was that explicit images of violence, crime, and sexual perversion could capture a child's imagination, "indoctrinating" and "conditioning" children to imitate the depraved panels they saw. Moreover, this was only one of his interventions on this theme. Another famous passage for which Wertham is most often cited is his account of Batman and Robin as representing a "wish dream of two homosexuals living together" (p. 190). His arguments have been too easily merged with those of the moral supporters and McCarthyite conservatives.

Furthermore, Wertham's perspective gained a fervent following in the Unit-ed States, contributing to the pressure on the US Senate to hold high-profile hearings on the comic book-crime link in 1950 and 1954.

The result was the censorious Comics Magazine Association of America Comics Code (Chute, 2017). It will take some time before the Comic Code is questioned.

A few years later, the next stage of revival is often called "Silver Age," where comic books began their "recovery," entering a new second superhero boom in the 1960s, especially thanks to Marvel Comics. The Silver Age is significant as it marked a period in the history of comic books when comic book sales had been fighting after controversy and finger-pointing regarding a link between adolescent violence and the reading of comic books. In the Silver Age, famous superheroes that are still popular among many of the general public today reemerged. The heroes of the Silver Age (such as Flash, The Hulk, Daredevil, Poison Ivy) were markedly "imperfect" and more "human," as opposed to the highly positive heroes of the Golden Age. The superheroes of the Silver Age were more relatable to many readers. Along with their superpowers, the heroes of the Silver Age also had human frailties and were often tormented by unresolved issues from their past. Many Silver Age heroes were linked in some way to outer space and other science-related subjects.

At the same time, and perhaps as a legacy left by the devastation of the Code, many cartoonists had begun to work outside the mainstream systems of publication and distribution, placing a new, less caricatured, and more profound emphasis on the expressive form of comics. It was an appeal surrounding the possibility of taking comics seriously and showing artistic skills on equal footing with other artists (painters, photographers, sculptors, etc.). This new era is recognized as the underground comics revolution, which took place largely in New York and San Francisco during the 1960s and 1970s. Underground comic books started to be called "comix," where the "x" refers to their adult nature, and it erupted as a reaction to ultraconservative and patriotic comics produced by large corporations and superhero characters. Additionally, this new type of comics often included critiques of the Comics Code through violent and sexually explicit images, expressing the rebellious spirit of the new postwar generation (Arffman, 2019).

In this perspective, several underground cartoonists would make use of existing well-known characters. In Victor Moscoso's surrealist-psychedelic Disney developments, for instance, Huey, Dewey, and Louie have sex with Daisy Duck, and a large-bosomed Minnie Mouse is shown in the same exercise with Mr Peanut and a giant frog (Zap Comix 4) (Arffman, 2019). The styles of drawing extended from amateur-like to professional, and the genres from realism to science fiction and fantasy; the atmosphere varied from toilet humor or racy sex to serious criticism of society or profound self-examination. Among the pioneers of the movement are often recognized Frank Stack

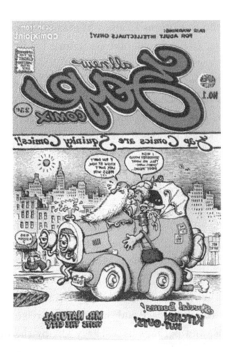

Fig. 1.2. Zap Comix.

(who had self-published arguably the first underground comic in *The Adventures of Jesus* (1962–1963) and Jack Jackson (Jaxon), who developed his own sacrilegious take on divinity in God Nose (1964). While opinions about the first underground comic may vary, there is no confusion as to which marked the breakthrough. Practically, all underground comix artists and publishers agree that it was Robert Crumb's Zap Comix, No. 1 (Fig. 1.2), published by Don Donahue in 1967.

Beginning in the 1970s, a further shift occurred, especially in the superhero scene, in what is often referred to as the Bronze Age of Comic Books, an informal name for a period in the history of comic books usually said to run from 1970 to 1985. In this phase, traditional superhero titles remained the industry's mainstay, but other elements began to flourish during the period. Particularly, darker plot elements and more socially relevant storylines featuring real-world issues, such as drug use, alcoholism, and environmental pollution, became prominent. This era also marks the beginning of the autobiographical phase of comics, where cartoonists begin to enact private life acts filled with fragility and unease. Comic books such as Justin Green's confessional *Binky Brown Meets the Holy Virgin Mary* (1972) (Fig. 1.3), the opening work of comics autobiography, offered the exact

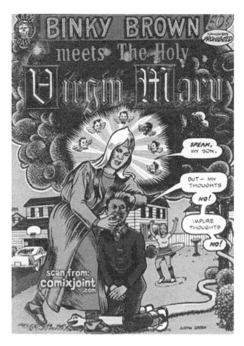

Fig. 1.3. Binky Brown Meets the Holy Virgin Mary.

contrary of what people would expect from comics. The story explores Green's struggle with scrupulosity, a form of Obsessive Compulsive Disorder, as the title character comes to Age as a Catholic in 1950s Chicago. Green explores the relationship between sexual repression and the formation of self-devised coping strategies which manifest as spectacular neurotic symptoms.

Perhaps the greatest surprise of the first comic autobiographers: not only their shocking fantasies or wild mind-altering experiences, but even their most personal histories could provide evocative connections with others, opening up a dialogue with audiences and a sense of communal experience and release (Gardner, 2012, p. 133). Green's work has inspired many authors, including Kominsky-Crumb's *Goldie: A Neurotic Woman*, published in 1972, and is often considered the first autobiographical comics by a woman. Through her memoir, Kominsky-Crumb concentrated her deepest insecurities, most embarrassing memories and repulsive traits into her comics alter-ego, yielding a self-loathing, vain, horny, ravenous, and rude character.[2]

The rise of the experimental and autonomous underground comix movement can be seen as an echo of the general blurring of boundaries between art and popular culture at the time. The tendency is visible in developments such

as pop art, which would take its subjects from the everyday phenomena of modern mass culture, including comics. In several ways, underground comix denoted a turning point in the development of the comics industry. Independent cartoonists helped comic books grow out of their infancy by introducing new adult-oriented subjects and strongly personal themes, often through experimental ways of expression.

We have seen that comics is a medium that thrives on contradictions and draws much of its appeal precisely from its refractoriness to labels. The emergence of a concise, seductive definition that also succeeds in building renewed commercial interest around it in the context of an increasingly suffocating market can only be seen as a desirable event. This is what has occurred, in recent years, with the gradual emergence of the affirmation of the graphic novel. In the last case, we consider what is referred to as the Modern Age of Comics, which begins in 1986 and extends to today. The Modern Age of Comics is a name for the Age of comics from the mid-1980s to the present. In this Age, comic characters are more psychologically complex and darker. Creators were becoming more well-known and independent comics started to become more popular.

3. UNREQUITED LOVE: FROM COMICS TO THE GRAPHIC NOVEL

Between the 1970s and 1980s, US strip comics evolved toward more extended and structured forms, aspiring to more complexity. *Graphic Novel* is an English noun phrase consisting of an adjective (graphic) and a noun (novel) and is used to refer to novel-like comics, with scope and ambitions similar to literary ones. The generalist press often uses it to describe graphic works distinct from, and hypothetically qualitatively superior to (Chute, 2017), comics. That being said, the graphic novel is neither a narrative form nor a genre in its own right, best described following Stephen E. Tabachnick's statement:

> *the graphic novel is an extended comic book freed of commercial constrictions, written by adults for adults, and able to tackle complex and sophisticated issues using all of the tools available to the best artists and writers. (2017, p. I)*

The authorship of the expression graphic novel is often attributed to Eisner, who is said by several authors to have coined the definition on the occasion of the publication of his short story collection *A Contract with God and Other Tenement Stories*, in 1978. As Mazur and Danner point out (1968, p. 181), while Eisner's works were not the first works about which the term graphic

novel was used, his "literary ambition and drive to bring serious comics – outside the conventional genres of superhero, science fiction or fantasy – into the broader mainstream did much to popularize the term and to jump-start the re-branding of comics as an art form for grown-ups." Eisner is not only a pioneer in using the graphic novel medium for fiction but also for autobiography and non-fiction: the stories in *A Contract with God* are based on New York neighborhoods that Eisner knew from his youth, and his *To the Heart of the Storm* was described by Eisner himself as "frankly autobiographical."

Following Eisner's example, the graphic novel grew in popularity and esteem, with Art Spiegelman[3] (Maus) and Alan Moore (Watchmen), among others. Graphic novels covering topics directly related to their authors, as is the case of Maus, help question the relation of postmodernity with the past.

One of the most interesting attempts is the edited publication *The Cambridge Companion to the Graphic Novel*, which examines the evolution of comic books into graphic novels and the distinct development of this art form in America and worldwide. Concerning other perspectives worldwide, an adult interest in graphic novel in Europe emerged in the early 1960s. As presented by Mazur and Danner (2014), in 1964, French publisher Eric Losfeld launched the first format of graphic novels for adult readers, which included the erotically tinged science fiction adventure *Barbarella* (1964) by Jean-Claude Forest and Belgian Guy Peellaerts' *Les Aventures de Jodelle* (1966). In 1965, the Italian Guido Crepax began his series of stories featuring the character *Valentina*, initially introduced in the journal Linus. Latin American comics have focused on the three countries that can claim to have had something akin to a comics industry: Argentina, Brazil, and Mexico. These countries had perhaps the richest tradition of comics and cartooning during the first half of the twentieth century. Nonetheless, there are a significant and growing number of comic studies in other Latin American countries, particularly Chile, Colombia, Cuba, and Peru.

However, numerous authors see the definition of graphic novel as the most successful attempt to create a name that distinguishes, precisely, the "adult" comic from the "childish" and unimportant comics, the educated and serious from the disengaged and semantically irrelevant. As reported by Chute (2017, p. 35), "I noticed a polite anxiety about terms: many people assume, for instance, that 'graphic novel,' a description that seems to confer a certain bookish sophistication, is preferable to something baser like 'comics' [...]" The Iranian cartoonist Marjane Satrapi also shuns graphic novel:

> *I don't very much like this term of graphic novel. I think they made up this term for the bourgeoisie not to be scared of comics. Like, Oh, this is the kind of comics you can read.*

The graphic novel appears to us, on the one hand, a form valued by comic book authors because it allows them freedom and authorial autonomy; while on the other, a limiting and almost insulting label: a reduction of the expressive powers of comics, a disciplining of creativity or, even worse, a way of denying the autonomous status of an expressive form (Benvenuti, 2019).

4. CARTOONISTS BEHIND THE SCENES

The comic form was born in the late nineteenth century of several ingredients, including accelerating urbanization and modernization. Having traced some of the crucial milestones within comics history and production: the comic book includes the newspaper strip, which originated in the United States in the 1890s; the comic strip, which came into being in the 1930s; and the so-called graphic novel, which came into being as such in the 1970s – it becomes incumbent upon us to dwell on some of the categories, of comics and artists, that have long remained behind the scenes. As discussed, comics is unprecedentedly popular in the art world, a feature not only of mainstream popular culture but also of university culture, the art world, and even global politics. Even with the substantial rise in the number of black and other minority superheroes, before the 1970s, there had been very few non-white superheroes (the Black Panther and the Falcon being notable exceptions). However, starting in the early 1970s, this began to change with the introduction of characters such as Marvel's Luke Cage (who was the first black superhero to star in his comic book in 1972, followed a year later by Black Panther in Jungle Action). However, some of these early minority superheroes have subsequently been criticized for perpetuating racial stereotypes.

Additionally, there were, and still are, artists who never got a chance to shine in major newspapers and publications simply because they belonged to some category. Diversity has always been problematic in comics. In the early days, minorities were nowhere to be found, and women were usually relegated to romantic figures.

Between the 1940s and 1980s, Chicago's Black press – from The Chicago Defender to the Negro Digest to self-published pamphlets – was home to some of the best cartoonists in America. Kept out of the pages of white-owned newspapers, Black cartoonists found space to address the joys, the horrors, and the everyday realities of Black life in America. Among the many examples, Tom Floyd, in 1969, produced an entire saga *Integration Is A...Bitch!* about a company hiring a black man and showing him off to prove how progressive they are. He used his personal experience as the only black man

working in a white environment in the 1960s, showcasing the absurd reality he was forced to be a part of. A meaningful change occurred with the assassination of Dr Martin Luther King Jr. in 1968; this event would change interest in comic strips dealing with discrimination in the black community topics. Among these, I mention Morrie Turner's *Dinky Fellas and Wee Pals* as he discussed racism within the comic pages of the mid-1960s newspaper. Turner was unhappy about this success, knowing that "America's guilt" was selling the comic strips. However, as months turned to years, interest in the Wee Pals continued to grow; Chicago's Black publishing world played a profound role as a platform for Black creativity, enabling a rigorous comics culture to emerge (Chute, 2021). Perhaps most significant in this regard was The Chicago Defender, the newspaper founded in 1905 that actively advocated for the Great Migration. Between the 1940s and 1980s, Chicago's Black press was home to some of the best cartoonists[4] in America, so the Museum of Contemporary Art Chicago offered several exhibitions of le a group of black cartoonists working in Chicago during these years.

Exclusion from the comics scene has involved several categories over time. Like many other spheres, the world of comic books is one that (white) men typically dominate. It is an unavoidable gender skew, yet what gets pushed to the forefront often hides a wealth of overlooked female talent. Women struggled for recognition in the male-dominated field of newspaper comic strips and thrived with popular characters like the Brinkley Girls, Flapper Fanny, Mopsy, and Brenda Starr. Women drew adventure, superhero, and romance stories for comic books during World War II, but their voices (and their comics) have been almost unheard of for a long time. Women came back to comics in the 1970s, with comics exploring themes more common to the female experience, such as love, sexuality, motherhood, creativity, discrimination, and independence. Aline Kominsky-Crumb is the mother of women's autobiographical comics. Aline's earliest comics focus on Goldie, a caricatured version of Aline that exaggerates every aspect of a post-pubescent, self-conscious, and over-sexed young woman. Aline's first story, "Goldie: A Neurotic Woman," appeared in 1972 in the premier issue of Wimmen's Comix, the first series entirely produced by women. She contributed to the series until 1975, when differences in feminist practice motivated her to create a new title, Twisted Sisters, with Diane Noomin.

Other remarkable cartoonists that took the scene during that time were artists Ramona Fradon (D.C.) and Marie Severin (Marvel) sketched mainstream characters like Aquaman and Plastic Man, while artists Trina Robbins, Barbara "Willy" Mendes, and Jewlie Goodvibes drew independent underground comix explicitly aimed at female readers.

As social media platforms have recently boomed, other marginalized people are reaching a wider audience. As such, the history of comics has slowly been rewritten to include the women, LGBTQ2S+ creators, trans folks, people with disabilities, people of color, and indigenous cartoonists who were not previously included but created work along the way. An example can be found in the work of the artist Mari Naomi the founder and curator of the influential *Cartoonists of Color* database (cartoonistsofcolor.com), the *Queer Cartoonists* database (queercartoonists.com), and the *Disabled Cartoonists* database (disabledcartoonists.com). These databases were created and are maintained as a way to spotlight marginalized comic creators and to create artistic connections and collaborations. The databases are used by booksellers, librarians, academics, editors, book publishers, event organizers, readers, and more. Cartoonists of Color (CoC) is punned to call out the acronym "PoC," which stands for "person of color." On this list, it is possible to find comic creators of various ethnicities who identify as non-white: African American, Korean Canadian, Indian Singaporian, Turkish American, Iranian British, Japanese American, and so many more. A queer cartoonist refers to; lesbian, gay, bisexual, pansexual, transgender, asexual–anyone who identifies as someone who belongs in the queer rainbow; comic creators, including artists, writers, letterers, colorists, editors, translators, and more.

The cultural movements associated with the comics industry are characterized by considerable asymmetry due to different-sized markets, the political regimes that can influence cultural production and diffusion, and marked discrepancies between cultural ecosystems (of which linguistic barriers constitute one variable, among others). Nevertheless, comics have long been considered a medium for art and political commentary through fictional characters. For instance, comic books for adults have become one of the most novel and colorful forms of cultural expression in Arabic, where talented artists have crafted stories to explain authoritarianism, resistance, war, sex, gender relations, and youth culture. Additionally, significant events such as the annual Cairocomix festival in Egypt and the Mahmoud Kahil Award in Lebanon evidence the importance of this cultural phenomenon.

Comic art and picture storytelling have had rich traditions in Asia yet have received little academic attention as only Japanese comics output has received close and by now, voluminous scrutiny. However, the comics industry is booming in nations and regions of Bangladesh, Cambodia, China, Hong Kong, India, Indonesia, Korea, Malaysia, Myanmar, and more.

The fourth chapter will give specific examples of graphic storytelling that often include more marginalized categories of artists.

5. THE EXCITING EVOLUTION OF COMICS PRODUCTION (AND WHY IT'S A BIG DEAL!)

The advent of the Internet changed enormously comics production and distribution. Very talented cartoonists have made the best use of the potential of webcomics, trying and transforming the traditional print format. The popularity of social media applications such as Facebook, Instagram, and Twitter, to name a few, are tools for artists and writers to gain exposure and use their work further for more proper gains. Technology and openness during this current time period have led to the rise of independent publishers. However, the first cartoons published online date back to a time before the wide spread of the Web as we understand it today. Around the early 1990s, some cartoonists began to explore the potential of the new digital sphere, opening small sites and online spaces to showcase their work. Among the first was Eric Monster Millikin, who began publishing online in 1985 through CompuServe, a comic strip, Witches and Stitches, a parody of the Wizard of Oz. The idea slowly caught on, and other authors decided to interact with this new possibility of enjoying their art, such as Joe Ekaitis, who in 1986 gave birth to T.H.E. Fox, a comic strip drawn with his Commodore 64. David Farley's *Doctor Fun* (1993) became the first true comic book of the Digital Age.

The legitimization of online comics as belonging to the world of the talking clouds came during this experimental period when Scott Adams' Dilbert was published on the web and landed in the digital world in 1995. Suddenly, interest in webcomics became widespread. As home connections began to spread, the presence of webcomics increased, driven by a more unrestricted enjoyment free of the previous structural limitations. Scott McCloud included the webcomic within his comics handbook, *Reinventing Comics* (2000). McCloud carefully analyzed this phenomenon, both in terms of creation (drawing in and for digital), distribution (i.e., how to publish webcomics on the Internet), and digital comics (i.e., creating comics designed expressly for the Web). Though not exactly greeted with enthusiasm, these reflections by McCloud had the merit of being an initial analysis of this digital comics revolution while offering insights into how to conceive of the evolution of the cartoonist profession in the time of the web.

The physical comic book medium perhaps underwent its most existential crisis with the COVID-19 pandemic in 2020. The sudden shift to online sales and the closure of comic bookstores have forced publishers and creators to adapt to new ways of reaching readers. The lockdowns implemented to curb the spread of the virus led to an increase in digital and physical comic sales through online outlets.

NOTES

1. The term *comics* is used as a singular noun when it refers to the medium itself (e.g., "*Comics is* a visual art form."), but becomes plural when referring to works collectively (e.g., "*Comics are* popular reading material.").

2. Priscilla Frank Meet The Feminist Artist Whose Crass Comics Were Way Ahead Of Their Time. Retrieved from https://www.huffpost.com/entry/aline-kominsky-crumb-interview_n_589e1bc8e4b094a129eaff86

3. It was, however, Art Spiegelman's work Maus that radically changed the form of autobiographical comics in shaping the reception of the form in the decades to come. Much has been written about Spiegelman's masterpiece, and the work has been especially of interest to scholars of the Holocaust, life writing, trauma, and narrative theory. He was also the first cartoonist in history to win the prestigious Pulitzer Prize in 1992.

4. From Jay Jackson's anti-racist time travel adventure serial Bungleton Green, to Morrie Turner's radical mixed-race strip Dinky Fellas, to the Afrofuturist comics of Yaoundé Olu and Turtel Onli, to National Book Award–winning novelist Charles Johnson's blistering and deeply funny gag cartoons.

REFERENCES

Arffman, P. (2019). Comics from the underground: Publishing revolutionary comic books in the 1960s and Early 1970s. *Journal of Popular Culture*, 52(1) (February), 169–198.

Auctions, H. (2004). Glossary of Comic Terms. Retrieved from https://comics.ha.com/c/ref/glos-sary.zx

Baetens, J., & Mélois, C. (2018). *Le Roman-photo*. Brussels: Le Lombard.

Benvenuti, G. (2019). Il Graphic Novel: una quaestio de centauris? In *La modernità letteraria e le declinazioni del visivo: arti, cinema, fotografia e nuove tecnologie* (Vol. 69, pp. 83–102). Pisa, ETS, «LA MODERNITÀ LETTERARIA».

Castaldi, S. (2004). Adult Fumetti and the postmodern: Poetics of Italian Sequential Art in the 1970s and 1980s. *Word and Image: A Journal of Verbal/Visual Enquiry*, 20(4), 271–282.

Chavanne, R. (2010). *Composition de la bande dessinée*. Montrouge: Éditions PLG.

Chute, H. (2008). Comics as literature? Reading graphic narrative. *PMLA*, 123(2) (March), 452–465.

Chute, H. (2011). Comics form and narrating lives. *Profession, 1*, 107–117.

Chute, H. (2017). *Why Comics? From underground to everywhere.* New York, NY: Harper.

Chute, H. (2021). *Black Lives Drawn and Stories of Struggle Told Through Comics.* Retrieved from https://www.nytimes.com/2021/06/17/books/review/its-life-as-i-see-it-charles-johnson-factory-summers-guy-delisle-wake-rebecca-hall.html

Cooke, S. (2019). A glossary of comic book terminology. Creator Resource. Retrieved from http://www.creatorresource.com/a-glossary-of-comic-book-terminology/

Duncan, R., & Smith, M. J. (2009). *The power of comics: History, form, and culture.* New York: Continuum.

Eisner, W. (1996). *Graphic storytelling and visual narrative.* New York: Poorhouse Press.

Flinn, M. C. (2013). High comics art: The Louvre and the Bande Dessinée. *European Comic Art, 6*(2) (December), 69–94.

Gardner, J. (2012). *Projections: Comics and the history of twenty-first-century storytelling.* Stanford, CA: Stanford University Press.

Gavaler, C., & Beavers, L. A. (2020). Clarifying closure. *Journal of Graphic Novels and Comics, 11*(2) (April), 182–211.

Gitelman, L. (2006). Introduction: Media as historical subjects. In L. Gitelman (Ed.), *Always already new* (pp. 1–22). Cambridge: MIT Press.

Gravett, P. (2013). *Comics art.* London: Tate Publishing.

Groensteen, T. (2007). *The system of comics.* Translated by Bart Beaty and Nick Nguyen. Jackson: University Press of Mississippi.

Grove, L. (2010). *Comics in French: The European Bande Dessinée in Context.* New York: Berghahn Books.

Harvey, R. C. (2010, August 20). Defining comics again: Another in the long list of unnecessarily complicated definitions. *The Comics Journal.* Retrieved from http://rcharvey.com/hindsight/define.html

Mazur, D., & Danner, A. (2014). *Comics: A global history, 1968 to the present* (p. 181). London: Thames & Hudson.

McCloud, S. (1994). *Understanding comics: The invisible art.* New York: Harper- Perennial.

McLuhan, M. (1964). *Understanding media: The extensions of man.* Cambridge: The MIT Press.

McNicol, S. (2017). The potential of educational comics as a health information medium. *Health Information & Libraries Journal, 34*, 20–31.

Menu, J. C. (2011). *La Bande dessinée et son double: Langage et marges de la bande dessinée; Perspectives pratiques, théoriques et éditoriales.* Paris: L'Association.

Meskin, A., & Cook, R. T. (Eds.). (2012). *The art of comics*: A *philosophical approach*. Chichester: Wiley-Blackwell.

Mikkonen, K. (2017). *The narratology of comic art.* New York: Routledge.

Molotiu, A. (2013). List of Terms for Comics Studies. *Comics Forum*, July 26. Retrieved from https://comicsforum.org/2013/07/26/list-of-terms-for-comics-studies-by-andrei-molotiu/

Pedri, N. (2022). *A concise dictionary of comics.* University Press of Mississippi/Jackson.

Pizzino, C. (2016). *Arresting development: Comics at the boundaries of literature.* Austin: University of Texas Press.

Randy, D., & Smith, M. (2009). *The power of comics: History, form, and culture.* New York: Continuum.

Saraceni, M. (2016). Relatedness: Aspects of textual connectivity in comics. In N. Cohn (Ed.), *The visual narrative reader* (pp. 115–129). London: Bloomsbury.

Smolderen, T. (2014). *The origins of comics: From William Hogarth to Winsor McCay.* Translated by Bart Beaty and Nick Nguyen. Jackson: University Press of Mississippi.

Tabachnick, S. (Ed.). (2017). *The Cambridge companion to the twentieth-century American novel and politics.* Cambridge: Cambridge University Press.

Taylor, K. J. (2007). *KA-BOOM! A dictionary of comic book words, symbols & Onomatopoeia, and Including … BZZURKK! The Thesaurus of Champions.* Morrisville, NC: Lulu Press.

Van As, T. (2013). Glossary of Comic Book Terms. How to Love Comics. Retrieved from https://www.howtolovecomics.com/comic-book-glossary-of-terms/

Walker, M. (1980 [2000]). *The Lexicon of Comicana.* Port Arthur, NY: Museum of Cartoon Art. Reprint, Bloomington, IN: iUniverse.

2

GRAPHIC SOCIAL SCIENCES

1. THE INTERPLAY OF SOCIAL SCIENCES AND COMICS

Once illustrated the complex and articulate history of comics, I can now address how social sciences can be represented in comics and the convergence of these two realms.

Over the past two decades, comics and graphic novels have been a growing subject of investigation among academic studies to the extent that "comics theory" itself has undergone a definite evolution (Kuttner, Sousanis, & Weaver-Hightower, 2017). This phenomenon has been particularly prevalent in English-speaking countries, where multiple authors have focused on diverse aspects, ranging from historical, sociological, anthropological, and media elements. This phenomenon has been particularly prevalent in English-speaking countries, where multiple authors have focused on diverse aspects, ranging from historical, sociological, anthropological to media elements One example is the work of Patricia Leavy, who, in her *Handbook of Arts-based Research* (2017), outlines, *inter alia*, the application of graphic techniques in the collection, interpretation, and dissemination of findings. So does Helen Kara's (2015) volume devoted to creative methods within social research, in which graphic novels and comics cover ample space. Even in Francophone contexts, comics are brought within scientific analyses but with a greater focus from the perspective of semiotics (Williams, 2012).

Within this current of comic studies, which began to flourish in the second decade of the twenty-first century, the interest of social sciences in this medium has been oriented on various aspects: the innovative, communicative aspect, the effects on readers, the conditions of production and reproduction of content, and, more generally, the way in which the medium transcends its field. Thus, this chapter seeks to analyze the academic production related to

comic studies and has a twofold objective. The first objective is to assess the diffusion and organize the theoretical and empirical corpus. The second is to legitimize the field of comics within the social sciences.

It is well-known that the visual components become a foundational part of understanding, with an active rather than ancillary role to writing and an additional opportunity for communication, action, and dissemination of a knowledge process.

The recent expansion of academic work in comic studies has undoubtedly shown a tendency toward textual analysis (without neglecting some valuable earlier ethnographies – Pustz, 1999, Brown, 2012), in part in an attempt to identify formal features of the medium that could be considered a measure of comics (as) "art" – and thus provide a kind of yardstick for analyzing (alleged) "individual artistic visions."

However, recognizing the historical and socio-cultural context within which the work is situated is essential, as it constitutes an integral aspect that cannot be overlooked.

The following sections will explore various approaches that have progressively incorporated comics within their scope. Considering the enormity of the phenomenon, a conscious decision was made on the perspectives to be presented, with an awareness that, in most cases, dimensions intersect and impact one another.

I argue that one cannot understand a comics – let alone comics as a whole – without understanding its social context. Wolfgang Max Faust has called comics "primarily a social phenomenon." With an explicit dose of enthusiasm from academia and beyond, the medium of comics started to be used to interrogate a wide variety of fields of study, further strengthening the interdisciplinary credentials of this new approach: comic studies. Aiming to provide a clear-cut definition, one can define comic studies as a diverse, interdisciplinary set of academic inquiry which has expanded in scope and size over the past 25 years (Heer & Worcester, 2009).

Sousanis (2015) explains that the narrative capacity of comics is unique compared to other "flat" modes of thinking and communicating exactly because they are able to present a visual understanding of reality. For a long time in Western scientific traditions, words have always dominated over images; adopting comics is, therefore, an epistemological challenge that subverts fixed, objectivist viewpoints in critical thought. This way of transforming elements constitutes the *raison d'etrè* of the contemporary debate surrounding the place of visual art in traditional academic research and discourse (Sossi, 2017). The emergence of graphic social science marks an exciting new trend in the public communication of social science, with comics being recognized as a valuable medium for this purpose (Carrigan, 2017).

Following Abbot's (1986) understanding that there are three types of language in comic art (narration, dialogue, and sound effects), the specific forms of comic books can be applied to scientific language. Specifically, narration is placed in square areas, usually colored yellow in comic books. This narration can follow typical data collection exchanges, in which dialogue between the researcher and participants is carried out in white "balloons," including small pointed projections pointing to the speaker. Unspoken thoughts follow a similar pattern, except the balloons are wider, and a series of small white circles leads to the thinker. Instead, this form traces the dialogues between the researcher and their self, configured, as Behar (1996, p. 14) reminds us, "the self who is also the spectator has to take us somewhere we couldn't otherwise get to." It is, therefore, not difficult to understand the panels that follow one another as the typical sequences of social research. It is possible to advance the hypothesis that other elements typical of comics have been increasingly incorporated not only into the mode of data collection (through activities with comics) but that the very conception of social research takes on new, more art-based characteristics. Indeed, today's research responds to a number of criteria typical of comic book formatting, revolving, for example, around the ability to captivate and engage the reader. In essence, through research done with images, an attempt is made to exploit the seductive power of visual elements and their inherent ability to pique interest and stimulate attention. That is why it is important to clearly communicate material that can promote understanding of the text and iconography. The clarity and effectiveness of the information presented can also affect how memorable the material is, making it easier to recall later. In addition, it is possible to consider how much the degree of emotionality elicited successfully conveys a portion of reality with greater intensity and coloring in a believable way, creating it from scratch or reproducing it.

Another potential use of comics in the context of social research concerns transformative data visualization, well described by Bach, Wang, Farinella, Murray-Rust, and Riche (2018). Specifically, it involves wanting to communicate findings more effectively by incorporating a new visualization that is both graphic and emotional. This new "humanization of data" has indeed also been taken up by Alamahodaei, Alberda, and Feigenbaum (2016), whose studies have recreated a fundamental epistemological framework from which to understand the role of comics in the social sciences. Specifically, their work is based on three pillars that aim to guide new training and evaluation of scientific data produced through comics. The three pillars contemplate an epistemological dimension, a methodological dimension, and a dimension of representational practices. The first pillar is the epistemological dimension, which is strongly inspired by the works of Patricia Hill Collins (1990) and Nancy Harding (1986), takes a critical framework intending to interrogate

what can be produced through comics. The second pillar is grounded on the methodological perspective where consideration is given from the methodological perspective, consideration is given to the material reality where data are produced and the ethical dimension that embraces the conditions from which information is gathered. Often, some data may be discarded or analyzed in a different dimension than initially intended. The third pillar related to the visual representation of the data produced centers around both esthetics and the inclusiveness of the language used to orient to a wide range of readers.

Despite the vast opportunities offered by comics in social research, as I will highlight in Chapter 3, one of the limits often highlighted by several authors is the perception of comics as "not a serious issue," therefore making scientific audience engagement challenging (Kuttner, Weaver-Hightower, & Sousanis, 2021). The use of humor, while often seen as valuable in medical research (Green & Myers, 2010), can also increase the perception of the research being trivialized (Darnhofer, 2018).

The researcher approaching the study and use of comics will therefore be called upon to make numerous choices that pervade the entire research process and subsequent presentation of results, often having to deal with a lack of confidence with respect to the "seriousness of the approach."

2. COMICS AND VISUAL STUDIES

Visual communication is all but new and is almost as old as social sciences. There are significant points of overlap between visual sociology and comic studies. O'Neill (2008, 2009, 2010) has consistently demonstrated the value and potential of combining biographical/narrative techniques with visual art through a practice-based methodology known as "ethno-mimesis." These visual arts-based, biographical approaches are valuable in creating a reflective space for ideas to emerge, especially when doing research with refugees and otherwise vulnerable or marginalized groups (O'Neill, 2010).

According to Mirzoeff (1999), visual culture is new precisely because of its focus on the visual as a place where meanings are created and contested. Western culture has consistently privileged the spoken word as the highest form of intellectual practice and seen visual representations as second-rate illustrations of ideas. Additionally, visual culture does not depend on pictures but instead the modern tendency to picture or visualize existence. In his classic sociological monograph *Art Worlds*, Becker (1982, p. 1) writes,

> *All artistic work, like all human activity, involves the joint activity of
> a number, often a large number, of people. Through their cooperation,
> the artwork we eventually see or hear comes to be and continues to be.*

In other words, the production of cultural objects such as art and literature – and, of course, comics – are fundamentally social activities. Methodology of socio-anthropological origin has often pioneered visual tools in education. Visual analytics encourages and supports experiments, bringing out the "taken for granted practices" that do not emerge with more traditional methodologies, and at the same time, fosters reflexivity, i.e., the principle that the narrative of experimenting with visual analytics is part of the research itself (Harper, 2012, p. 39). Just as even "face-to-face interaction in general, and conversation in particular, is far from being a matter of words alone" (Goffman, 1988, p. 14), images, precisely because of their polysemous character, also "ooze" with meaning. The methodology of visual analysis fosters a sense of participation. Harvey (1979), a longtime contributor to *The Comics Journal* and one of the industry's most enduring, prodigious, and personably provocative commentators on comics culture, wrote in an issue of the *Journal of Popular Culture* that was devoted to comics that the visual–verbal interaction in comics is not constant. The use and sequences of images should be considered as data, congruent with a scientific methodology, and therefore be distinguished from the modern forms of narration of digital stories, definitively leaving both the world of spectacle (Debord, 1977) and the cultural vernacular of photography (Zuromskis, 2013).

Nevertheless, there is no doubt that visual displays appear in sociology before the twentieth century. It is interesting to understand how art, in its varied forms, has been able to appropriate the knowledge produced by university research. Specifically, with this first section, I seek to contextualize how comic books contribute to societal knowledge in different ways that complement academic research. The study of the production of comics is arguably the most compared to other mediums as it requires a high level of access to a particular set of people, the producers themselves. Nevertheless, as with other visual techniques, comics have been a topic of academic curiosity and debate for some time, with studies dating as far back as the 1940s (Sones, 1944). Significant work by comic creators like Eisner (1996) and McCloud (1994) have not only influenced the production of comics but have proven that the medium of comics can be used to scrutinize itself creatively and rigorously and works like this form a significant part of the principle of Comics Studies literature.

Over time, within social research, visual methods have increasingly been incorporated into research studies traditionally set up with interviews and focus groups (Pettinger, Letherby, Parsons, et al., 2018), within the qualitative approach, and with surveys and questionnaires (Ball & Gilligan, 2010) within the quantitative approach. There are important questions regarding the boundaries between comics and other visual media. Whether seemingly

simple, comics are a deceptively complex medium to define. Compared to other techniques, comics offer a novel contribution to visual studies. For example, among the most appreciated and mentioned methods, we can take photo-voice, which is recognized as one of the techniques that can engage participants and encourage reflection on issues beyond what can be achieved with traditional interview techniques (Fearon, 2019). In addition, photo-voice has often been presented as a technique that can sharpen participants' memories (Fearon, 2019). However, the main difference that can be mentioned between this technique and visual methods that often seek to focus on reflections of individual experiences through researcher-provided or participant-generated images, the use of a comic book-based method can offer more critical distance. The visual/verbal encounter can also generate some advantages, certainly different from other art forms. The drawings placed in each comic book panel bear a crucial resemblance to other two-dimensional art forms; however, what makes comic book narratives so typical is the construction of a written language that composes and combines with the images present, thus imposing new frontiers in the perception of the image.

Comics and vignettes can be advantageous in research on sensitive topics where the participants may not feel comfortable discussing their situation and may conceal the truth about their actions or beliefs (Gourlay et al., 2014). Comics can also be fruitful in encouraging participants to reveal personal experiences when they feel comfortable in doing so.

In Chapter 3, the basic units of comics will be explained, which will serve to appreciate the medium's specificity.

3. COMICS IN EDUCATION

As noted by Akcanca (2020), comics, which attract attention with their adaptation to changing conditions in the historical process, found particular success in education. Specifically, Karagöz (2018) added that comics have found space in this field by providing more accessible elements to their informative purpose, especially in a field such as Science. Comics can be used to convey abstract concepts to students in an entertaining way, developing a new process of learning and producing a transformation of a new genre within the comics industry. Comics started to be accepted in a new vision of alternative education. Contrary to what we might think, this process has a longstanding application and should not be perceived only as today's effective teaching materials. Hutchinson, already in 1949, carried out an experiment, cooperatively

conducted by the Curriculum Laboratory of the University of Pittsburgh and the Comics Workshop of New York University, in the use of comics as instructional materials in the classroom. She identified that the everyday activities of children involve the same subject material that constitutes the school curriculum – geography, history, science, language, and other academic areas were present in an unorganized form in day-to-day activities. So reading comics, a traditional and well-nigh universal out-of-school activity might positively affect students' motivation and participation in the course. This pedagogical turn, however, was already pointed out by Gruenberg in 1944, according to whom, in every kind of society, it takes different time to establish and recognize a set of new ideas or devices or practices. Campbell (1977) attempted to use comic books as an alternative to other material in a reading program in a school where the average fourth grader's reading test score was in the lowest 25 per cent of the norm distribution for large urban cities.

Additionally, the school population was predominantly black, with most students reading below grade level. Through comics, Campbell aimed to increase the vocabulary and comprehension of his students. Comics, as other media of communication, can be used for different purposes, including that of expressing views and attitudes, preferences and bias.

So if in the beginning comic books were perceived as childish medium with no social responsibility and no ambition to become a social force, they gradually acquired scientific "respect." This transformation was also accompanied by a change in comics' content within the market, where they acquired some of the refinements demanded from any cultural instrument to establish themselves as a cultural product. Comics improved in details and language, gradually filling the gap between everyday and academic language (Krashen, 1993). Additionally, they have been obliged to adjust themselves to criticisms and opposition. This new genre was named "educational comics" Akcanca (2020).

Cary (2004) demonstrates the unique advantages of the comics medium in multi-lingual educational contexts, highlighting the value of visual means of communicating where languages differ. For instance, English language learners can take advantage of the use of comics because many graphic novels introduce idioms, colloquialisms, and onomatopoeia. These texts can help students learn the metaphoric language.

Berkowitz and Packer (2001, p. 17) argue that comics provide a "wealth of pedagogical opportunities" for both children and adults. Through these motivational and educational tools, a teacher can focus on drawing technique, history, esthetics, empowerment, or creative writing. In line with this, Topkaya and Yilar (2015) showed in their research that comic books used within educational activities could make the course content more engaging. Using

funny characters, vivid images, and short stories, children's imagination is stimulated in a positive way and affects their motivation toward the lesson. As mentioned in Chapter 1, the juxtaposition of text and images might create a new form of communication, expanding the reader's attraction and making the topic easier to understand (McVicker, 2007). Comics can also be considered a suitable teaching tool for the education of large masses (Weitkamp & Burnet, 2007) and can be produced, distributed, and used with widespread participation via online formats at a relatively low cost (Hands, Shaw, Gibson, & Miller, 2018).

From an empirical perspective, Lawrence, Lin, and Irwin (2017) have conducted extensive research on using graphic novels to help adolescents develop critical thinking. According to Erin Polgreen, "comic book narratives can work across platforms, engage younger, more visually oriented readers, and transcend cultural boundaries" (2014, p. 12). Indeed, today, it is almost commonplace to say that comics and cartoons are valuable mediums to be used in multimodal teaching and literacy activities (El Refaie, 2010).

Considering these factors, a growing number of authors (Nakazawa, 2005; Nalu, 2011; Short, Randolph-Seng, & McKenny, 2013) see graphic social science as a possibility to use graphic novels in social research. But with some clarifications. First, the language of presentation must be precise, the selection of words must be meticulous, and every nuance must be thoughtful. Whether it is true that comics, like poetry, seems to allow more leeway in terms of meaning, it is at the same time true that their preparation is very complex. Words and images are called to a harmonious fusion. The answer to the question, "Should I read the words first or see the images?" must be equally simple: there is no strict and precise order. As Harvey (1979) described, the two universes (textual and graphic) are linked by a deep interdependence and constant interaction.

4. COMICS AND ANTHROPOLOGY

From its beginnings, anthropology's attention to the visual aspects of cultures has been dominated by a desire to capture images of people and events in action, then in motion, using the technical means that were gradually becoming available. In its original connection to biology and colonial dehumanization, anthropology has almost certainly shown an earlier interest in visually representing its research subjects. Balinese Character by Margaret Mead and Gregory Bateson was considered the first ethnography based primarily on the study of photographs taken during the field research. Mead and

Bateson's basic idea was the concept of ethos (a culturally standardized system of organizing the instincts and emotions of individuals).

Anthropological research that first made use of the visual medium mainly adopted forms such as photography and film, inspiring with increasing intensity to abandon the written word in favor of other, more accessible forms of expression.

All at most, authors struggled to find problematizing representations, as the work of MacDougall in 1997 showed to the scientific community. As an ethnographic filmmaker and writer on visual anthropology and documentary cinema, MacDougall affirmed that, while the text was capable of theory and analysis, the meaning of images was considered less easily controlled and thus more likely to be misunderstood or misinterpreted.

Pinney, an anthropologist and prominent scholar of Indian photography, argues that the background in Indian photography produced in Negda City is a space of geographic exploration. Unlike Bourdieu, according to whom photography tends to solemnize what it photographs and what it shows of an individual is not their personal identity but the social role, Pinney argues how the photographic studio becomes a place not so much for social solemnization but for individual exploration of what does not yet exist in the social world. Another example of anthropological research in images is that of Timothy Asch and Napoleon Chagnon with the Yanomami of Venezuela. As soon as they arrive in the village of Mishimishimaboweiteri, a conflict breaks out, and the situation escalates. Asch films without knowing what is going on, and those who record the sounds do the same.

Over time, anthropological research and the work of ethnographers have relied on increasingly varied visual images and technologies. The representation of different cultures, lives, and interactions between different social groups has thus been mediated through the introduction of new means of conducting social research. In this sense, what can be called graphic anthropology brings drawing closer to the mode of social inquiry. Most commonly, artistic sketching, vignettes, and drawing as a process have been employed with increasing enthusiasm by cultural anthropologists as visual research methods during fieldwork. Among the various possibilities for use, I mention writing ethnographic notes in the form of drawings, inviting research participants to create or comment on drawings, and going as far as turning the entire research report into an ethnographic cartoon.

One of the prime examples is the work *I Swear I Saw This*, which records visionary anthropologist Michael Taussig's reflections on workbooks he kept during 40 years of travel in Colombia. Taking as his point of departure a

drawing made in Medellin in 2006 and its caption, *I Swear I Saw This*, Taussig sees the fieldwork notebook as a type of modernist literature and the place where writers and other creators first elaborate the imaginative logic of discovery. Taussig's production mixes the raw material of observation with his fervent imagination, which is graphically rendered to the reader with the use of charcoal pencils, watercolors, and newspaper clippings that seeks to blend the researcher's way of observing with the reality that manifests itself before his eyes, similar to the surreal cut-up technique of Brion Gysin and William Burroughs. As Taussig expertly recounts, his drawings

> *surpass the realism of the fieldworker's notebook, that urge to put*
> *everything in writing as it was, that relentless drive that makes*
> *you feel sick when the very words you write seem to obliterate the*
> *reality you are writing about. However, this can be miraculously*
> *checked, and even reversed, by a drawing – (…) because drawings*
> *have the capacity to go in a completely different direction. (p. 13)*

The possibility of expressing oneself in a mode other than verbal does not only benefit research participants by unveiling new opportunities for expression. At the same time, ethnographic drawing can help anthropologists shake the hectic routine of documentation in the field of holding diaries and notebooks.

In this sense, cartoon anthropology can lead to a mutual discovery of history between the observer and the observed, differentiating itself from other techniques (including photography) precisely by relating the inner and outer worlds. Can we thus conceive of field notes as occasional moments of "still life in which writing hesitates between documentation and meditation?" (p. 52).

Comics were also used by Louise Ahrens (2008) in *The Real Cost of Prisons*, which offers a radical and visual critique of the US prison system, incorporating statistics and empirical field research to examine the causes and consequences of mass incarceration through the medium of comics. The logic employed was to "combine drawings and simple language to present complex ideas and concepts" (Ahrens, 2008, p. 9). Another example is the work of Ross (2015), whose highly praised book *Filmish* presents a rigorously argued and academically referenced history of film and film studies in comics form.

The potential of comics is not only manifested in communication but is also an effective medium in the formulation of thought. With its unique property of combining words with images, comics demand complex concepts

and ideas to be explained in a simple way, using compelling and coherent visual and verbal narratives. It often involves transferring academic knowledge into the hands of a non-expert and often heterogeneous audience in terms of education and status. We can, in this sense, recall the work of Gallman (2009), who attempted to reconstruct teachers' identities in training through drawing. Specifically, the author sought to produce a graphic novel that would tell, through drawing teachers, how they imagined their private and professional futures through an emotional and visual vision that could not be reproduced through online narratives.

As in many other cases, the creation and analysis of comics in the anthropological context have often fostered interdisciplinary overlaps with the sciences, the medical and digital humanities, public health, visual culture studies, and the visual and literary arts.

Although graphic anthropology is related to visual anthropology, the strong interdisciplinary articulations of drawing as a mode of research, practice, and creation, combined with the focus on comics as a site of cultural production, mean that "graphic design" is a rich domain of anthropological inquiry in its own right.

As another clear-cut example of how to transform a research report into an accessible comics, anthropologists Aleksandra Bartoszko and Anne Birgitte Leseth published a research report as a comic book – together with cartoonist Marcin Ponomarew (https://anthrocomics.wordpress.com). This study was conducted to assess the friendliness and accessibility of facilities and information services in terms of social and cultural diversity at the campus of Oslo University College. The book became a collection of situations, as shown by the images below (Fig. 2.1), in which cultural stereotypes are made visually tangible.

Among the main problems that often arise with the use of visual media is the lack of anonymity guaranteed to participants. In this sense, comics, while not lacking in profound ethical implications that will be the subject of Chapter 3, can ensure confidentiality of information since the details of the person's identity are not disclosed while keeping the original message and visual style intact. Some drawings represent situations that we have observed; others are situations that our informants or we have experienced. They are often representations of emotions and feelings. Some represent stories we have been told, and others represent our analysis of documents and situations on campus as a workplace. In all cases, and as mentioned above, ethical issues remain central and will be explored in more detail in a few pages.

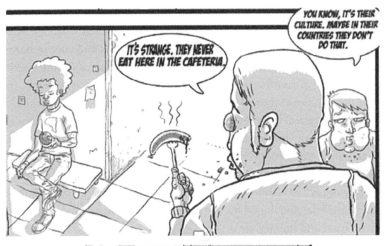

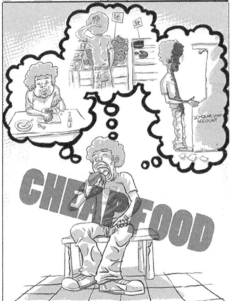

Stereotypes: Culture or money? Cartoon: Marcin Ponomarew

Fig. 2 1. Social and Cultural Diversity.

5. COMICS AND SOCIOLOGY

This section does not clearly differ from the previous ones since the combination of sociological research and comics fits into the currents already described (anthropology, visual studies, and education). Moreover, sociological studies have always looked closely at the cultural production of different

media and the social effects of progressive mass communication. However, unlike the other traditional communication channels (television, cinema, and radio), there has been no development related to technological advances. On the contrary, there has been an advancement in the logic of creating the medium, which, as we know, had already been in use for centuries thanks to the production and distribution of serial graphics.

Sociological studies thus began to take an interest in the study of comics due to a number of factors related mainly to the fact that the immense mass distribution of comics occurred in the historical/social context in which research on media analysis, such as the work of Paul Lazarsfeld (1940) or Robert K. Merton (1946), was expanding significantly. In other words, the great popularity of comics coincided with the expansion of sociology and its empirical research in academia, particularly in the United States.

As mentioned earlier, the enjoyment of comics was at first related to the world of education, particularly among young readers. This contributed to building a kind of prejudice concerning the "seriousness" of the medium, especially in academia (Berger, 1972; Groensteen, 2008; Lent, 2010). One of the contributions that certainly created an initial openness to the study of comics as a social and popular medium, whether or not it is a canonically sociological text, is Umberto Eco's *Apocalyptic and Integrated*, published in 1964. In his semiotic studies, Umberto Eco has ranged over various communication fields, including mass culture. In reference to the comic strip, Eco argues how it falls into that group of communicative tools to which the most widespread media, such as radio, television, and newspapers, belong. In addition, the fact that the comic strip has undergone an important evolution since it began as a completely marginal cultural phenomenon and gradually carved out an increasingly important space within society over the centuries is emphasized. Along this path, marked by various milestones, comics have established their own language and means of expression, developing various styles, tastes, and traditions; these elements have been fundamental to understand comics as an artistic phenomenon second to none other. According to Eco, these characteristics constitute the salient elements for making comics an object of academic study.

Following these premises, Berger's (1972) essay *Li'l Abner* constitutes the first monographic study of a series of comic strips by bringing, within the scholarly debate, the breadth and complexity of this medium and the difficulties researchers encounter in its analysis. Specifically, *Li'l Abner* is an American satirical strip that appeared in several newspapers in the United States, Canada, and Europe, featuring a fictional clan of hillbillies in the poor mountain village of Dogpatch, United States. Written and drawn by Al Capp

(1909–1979), the strip was published for 43 years – blatantly satirizing American society, aiming to encourage the superiority of the middle classes over the hillbilly represented by Abner, a lower-class, uneducated anti-hero, the opposite of the American dream. Berger's analysis explains the social significance of images, texts, present icons, and latent and manifest functions by deploying, with a robust methodological corpus, the crucial function of comics in understanding social contexts and processes. One of the studies closest to a sociological analysis of comics is the one by Luc Boltanski for the first issue of *Actes de la Recerche en Sciencies Sociales* (Boltanski, 1975). This work examines the remarkable cultural legitimacy of French comics in the 1970s, which had achieved commercial success with *Tintin* or *Asterix and Obelix* and magazines such as *Pilote*. The transition highlighted by Boltanski is the leap of comics to an object of cultural consumption without losing its connection to the fields of art and media, mechanisms that will provide both the medium and its producers with legitimacy and recognition. In parallel, Boltanski delves into the academic analysis of comics and the mechanisms of legitimation and formation of the device of production, reproduction, and celebration that accompanies the transformation of the comics field into a hegemonic field. One of the central aspects of his work is precisely the process of legitimation and acceptance of comics by the academic and intellectual world.

The need to create and institutionalize a sociology of comics has been increasingly felt over time by numerous authors. Nevertheless, practically since the mid-1990s, a field of comic studies has emerged heir to, among others, Eco, Boltanski, and Dorfman.

Recently, using the transnational comics publishing industry in Japan and the United States as a case study, Casey Brienza (2010) has shown how the conditions and modes of comics production help determine the particular types of texts created. In looking at what is characterized as methodological approaches to the study of comics, which align with those of any cultural object, Brienza highlights the study of (1) its production and transmission or dissemination, (2) the construction of its message, and (3) its reception and appropriation.

This tripartition originates from the model developed earlier by Thompson (1990, p. 303), who argues how each of these areas of inquiry is distinct. From a sociological point of view, comic strips provide a supporting and complementary element to empirical fieldwork, especially in relation to the visual support traditionally provided by photographs, videos, and diagrams, which have been widely used as supporting tools in sociological analysis and are related to visual sociology (Harper, 2012). In addition, comics reinforce sociological analysis of macro and micro social issues.

Currently, the use of comics has gone even further in exploring social reality, in which graphic narratives accompany several new social genres, as we will see in Chapter 4. To date, it is possible to mention a vast network of sociologists and social scientists who carry out publications having comics as their subject, such as the case of the *Sociorama* editorial line (in French).

Each album in the "Sociorama" collection is based on the work of contemporary sociologists who, in the field, have observed and mapped collective behaviors, individual trajectories, and the links that can be established between the components of specific social categories. These studies sometimes open doors to professional environments that are usually relatively closed, thereby giving us a glimpse behind the scenes that we know little about. Recently, an important sociological, anthropological, and social science debate has also emerged, or perhaps more aptly "renewed," around these and other "alternative scripts," as evidenced, for example, by the panel discussion held at L'École des hautes études en sciences sociales (EHESS) or Palgrave publishing house's series, Studies in Comics and Graphic Novels – speaking of them in terms of a "nascent discipline." Barberis and Gruning have well shown in their article "Doing Social Sciences Via Comics and Graphic Novels" this "scientific-path". The first journal specializing in comics, *Inks*, was founded in 1994 by Ohio State University Press. It received a more solid formalization only in 2016. It preceded *The International Journal of Comic Art*, founded in 1999, and the interdisciplinary journal of comics studies, *ImageTexT*, founded five years later. More recently, *The Journal of Graphic Novels and Comics*, the *Journal of Sequential Art in Narrative Education* (hosted by the University of Nebraska Lincoln), and the journal *Studies in Comics* were all founded in 2010, and the journal *The Comic Grid: Journal of Comics Scholarship* was founded in 2013.

Nevertheless, as of June 2017, the Graphic Social Sciences Research Network is officially established. This network aims to provide a space for comparison for scholars, artists, and publishers to more formally consider the practical and theoretical implications of integrating graphics into social science (Priego, 2016). A similar attempt was introduced by Helen Kara (2015), who placed graphic social science in the context of creative methods.

In the next chapter, I will delve into the practical application of comics in different phases of social research. This will involve showcasing specific examples and demonstrating how comics can effectively be utilized as a valuable tool for data collection, analysis, and presentation. By examining these practical applications, we can gain a deeper understanding of the potential impact, benefits, and limitations that comics bring to the field.

REFERENCES

Abbot, L. L. (1986). Comic art: Characteristics and potentialities of a narrative medium. *Journal of Popular Culture, 19*, 155–176.

Ahrens, L. (2008). *The real cost of prisons comix*. Oakland, CA: PM Press.

Akcanca, N. (2020). An alternative teaching tool in science education: Educational comics. *International Online Journal of Education and Teaching (IOJET), 7*(4), 1550–1570.

Alamahodaei, A., Alberda, A., & Feigenbaum, A. (2016, November). Giving graphic narratives to numbers. Paper presented at An Agenda for Graphic Social Science, London.

Bach, B., Wang, Z., Farinella, M., Murray-Rust, D., & Riche, N. H. (2018). Design patterns for data comics. In *Proceedings of the 2018 CHI Conference on Human Factors in Computing Systems – CHI 18*.

Ball, S., & Gilligan, C. (2010). Visualising migration and social division: Insights from social sciences and the visual arts. *Forum Qualitative Sozialforschung/Forum: Qualitative Social Research, 11*(2), Article 26. http://nbn-resolving.de/urn:nbn:de:0114-fqs1002265.

Barberis, E., Grüning, B., Hamdy, S., Nye, C., & Dragone, F. (2021). EthnoGRAPHIC: An Interview. *Sociologica, 15*(1), 291–298. doi:10.6092/issn.1971-8853/12778

Becker, H. (1982). *Art worlds*. Berkeley, CA: University of California Press.

Behar, R. (1996). *The vulnerable observer: Anthropology that breaks your heart*. Boston, MA: Beacon Press.

Berger, J. (1972). *Ways of seeing*. London: BBC Press and Harmondsworth: Penguin.

Berkowitz, J., & Packer, T. (2001). Heroes in the classroom: Comic books in art education. *Art Education, 54*(6), 12–18.

Boltanski, L. (1975). La constitution du champ de la bande dessinée. *Actes de la Recherche en sciences sociales, 1*(Janvier), 37–59.

Brienza, C. (2010). Producing comics culture: A sociological approach to the study of comics. *Journal of Graphic Novels and Comics, 1–2*, 105–119.

Brown, J. A. (2012). Ethnography: Wearing One's Fandom. In M. J. Smith & R. Duncan (Eds.), *Critical approaches to comics: Theories and methods* (pp. 280–290). New York: Routledge.

Campbell, R. W. (1977). *Using comic books as an alternative supplement to the basal reading program at Albert Sidney Johnston Elementary School.* Dissertations/Theses. Retrieved from https://eric.ed.gov/?id=ED141797

CampeERIC/RCS: The Careful Use of Comic Books Author(s): Karl Koenke Source: The Reading Teacher, *Feb.*, 1981, Vol. *34*, No. 5 (Feb., 1981), pp. 592–595.

Carrigan, M. (2017, June 21). What is graphic social science? [Blog post]. Retrieved from https://markcarrigan.net/2017/06/21/what-is-graphic-social-science/

Cary, S. (2004). *Going graphic: Comics at work in the multilingual classroom.* Portsmouth. NH: Heinneman.

Collins, P. H. (1990). *Black feminist thought: Knowledge, consciousness, and the politics of empowerment.* Boston, MA: Unwin Hyman.

Darnhofer, I. (2018). Using comic-style posters for engaging participants and for promoting researcher reflexivity.

Debord, G. (1977). *The society of the spectacle.* London: Black and Red.

Eisner, W. (1985). *Comics and sequential art.* Florida: Poorhouse Press.

Eisner, W. (1996). *Graphic storytelling and visual narrative.* Florida: Poorhouse Press.

El Refaie, E. (2010). Subjective time in David B's graphic memoir 'Epileptic'. *Studies in Comics*, 1(2), 281–299.

Fearon, K. (2019). 'Have you ever talked to any women with Turner syndrome?' Using universal design and photo elicitation interviews in research with women with mild cognitive impairment. *Methodological Innovations*, *12*(2), 205979911984193.

Gallman, S. (2009). The truthful messenger: Visual methods and representation in qualitative research in education. *Qualitative Research*, 9(2), 197–217.

Goffman, E. (1988). *Exploring the interaction order.* Cambridge: Cambridge Polity Press.

Gourlay, A., Mshana, G., Birdthistle, I., Bulugu, G., Zaba, B., & Urassa, M. (2014). Using vignettes in qualitative research to explore barriers and facilitating factors to the uptake of prevention of mother-to-child transmission services in rural Tanzania: A critical analysis. *BMC Medical Research Methodology*, Feb 11, *14*, 21. doi: 10.1186/1471-2288-14-21. PMID: 24512206; PMCID: PMC3922981.

Green, M. J., & Myers, K. R. (2010). Graphic medicine: Use of comics in medical education and patient care. *BMJ: British Medical Journal, 340*(7746) (March), 574–577.

Groensteen, T. (2008). Why are comics still in search of cultural legitimization. In J. Heer & K. Worcester (Eds.), *A comics studies reader* (pp. 3–11). Jackson: University Press of Mississippi.

Gruenberg, S. (1944). The comics as a social force. *Journal of Educational Sociology, 18*, 204–213.

Hands, T., Shaw, A., Gibson, M., & Miller, K. (2018). People and their plants: The effect of an educational comic on gardening intentions. *Urban Forestry and Urban Greening, 30*, 132–137.

Harding, S. (1986). *The science question in feminism.* Cornell: Cornell University Press.

Harper, D. (2012). *Visual sociology.* London: Routledge.

Harvey, R. C. (1979). The aesthetics of the comic strip. *Journal of Popular Culture, 12*, 640–652.

Heer, J., & Worcester, K. (Eds.) (2009). *A comics studies reader.* Jackson: University Press of Mississippi.

Hughes, J. M., King, A., Perkins, P., & Fuke, V. (2011). Adolescents and "Autographics": Reading and writing coming-of-age graphic novels. *Journal of Adolescent & Adult Literacy, 54*(8), 601–612.

Hutchinson, K. (1949). An experiment in the use of comics as instructional material. *Journal of Educational Sociology, 23*, 236–245.

Kara, H. (2015). *Creative research methods in the social sciences.* Bristol: Policy Press.

Karagöz, B. (2018). Applicability to the strategies of determining and interpreting interdisciplinary content of educational comic novels: The case of Adam Olmus? Cocuklar and Kahraman Kadınlarımız series. *Erzincan University Journal of Educational Faculty, 20*(3), 637–661.

Krashen, S. (1993). *The power of reading: Insights from the research university of Michigan.* Exeter: Libraries Unlimited.

Kuttner, P., Sousanis, N., & Weaver-Hightower, M. B. (2017). How to draw comics the scholarly way: Creating comics-based research in the

academy. In P. Leavy (Ed.), *Handbook of arts-based research* (pp. 396–424). New York: Guilford Press.

Kuttner, P. J., Weaver-Hightower, M. B., & Sousanis, N. (2021). Comics-based research: The affordances of comics for research across disciplines. *Qualitative Research, 21*(2), 195–214.

Lawrence, J., Lin, C.-C., & Irwin, R. (2017). Images, speech balloons, and artful representation: Comics as visual narratives of early career teachers. *SANE Journal: Sequential Art Narrative in Education, 2*(2), 1–3.

Lazarsfeld, P. F. (1940). *Radio and the printed page.* New York: Duell, Sloan and Pearce.

Leavy, P. (2017) (Ed.). *Handbook of arts-based research.* New York: Guilford Press.

Lent, J. A. (2010). The winding, pot-holed road of comic art scholarship. *Studies in Comics, 1*(1), 7–33.

MacDougall, D. (1997). The visual in anthropology. In M. Banks & H. Morphy (Eds.), *Re-thinking visual anthropology* (pp. 276–295). New Haven: Yale University Press.

McCloud, S. (1994). *Understanding comics: The invisible art.* New York: Harper Perennial.

McVicker, C. J. (2007). Comic strips as a text structure for learning to read. *The Reading Teacher, 61*(1), 85–88.

Merton, R. K. (1946). *Mass persuasion.* New York: Harper and Row.

Mirzoeff, N. (1999). *An introduction to visual culture.* London: Routledge.

Nakazawa, J. (2005). Development of manga (comic book) literacy in children. In D. Shwalb, J. Nakazawa, & B. Shwalb (Eds.), *Applied developmental psychology: Theory, practice, and research from Japan* (23–42). Greenwich: Information Age Publishing.

Nalu, A. (2011). Comics as a cognitive training medium for expert decision making. *Proceedings of the Human Factors and Ergonomics Society Annual Meeting, 55,* 2123–2127.

O'Neill, M. (2008). Transnational refugees: The transformative role of art? *Forum: Qualitative Sozialforschung/Qualitative Social Research, 9*(2), 59.

O'Neill, M. (2009). Making connections: Ethno-mimesis, migration and diaspora. *Journal of Psychoanalysis: Culture and Society, 14*(3), 289–302.

O'Neill, M. (2010). *Asylum, migration and community*. Bristol: Policy Press.

Pettinger, C., Letherby, G., Parsons, J. M., Withers, L., Cunningham, M., Whiteford, A., ... Sutton, C. (2018). Employing participatory methods to engage an under-researched group: Opportunities and challenges. *Methodological Innovations, 11*(1). https://doi.org/10.1177/2059799118769820.

Polgreen, E. (2014). The core of story. *The Promise of Comics Journalism. Nieman Reports Spring, 68*(2), 12.

Priego, E. (2016). Comics as research, comics for impact: The case of higher fees, higher debts. *The Comics Grid: Journal of Comics Scholarship, 6*, 16.

Pustz, M. J. (1999). *Comic book culture: Fanboys and true believers*. Jackson: University Press of Mississippi.

Ross, E. (2015). *Filmish: A graphic journey through film [Comic]*. London: Self-Made Hero.

Short, J., Randolph-Seng, B., & McKenny, A. (2013). Graphic presentation: An empirical examination of the graphic novel approach to communicate business concepts. *Business Communication Quarterly, 76*, 273–303.

Sones, W. W. D. (1944). The comics and instructional method. *The Journal of Educational Sociology, 18*(4), 232–240.

Sossi, D. (2017). Unflattening by Nick Sousanis. *Visual Studies, 32*(2), 193–194.

Sousanis, N. (2015). *Unflattening*. Cambridge, MA: Harvard University Press.

Taussig, M. (2011). *I Swear I Saw This*. Chicago, IL: The University of Chicago Press.

Thompson, J. B. (1990). *Ideology and modern culture: Critical social theory in the era of mass communication*. Stanford, CA: Stanford University Press.

Topkaya, Y., & Yilar, B. (2015). Analysis of student views related to educative comics. *Route Educational and Social Science Journal, 2*(3), 106–117.

Weitkamp, E., & Burnet, F. (2007). The chemedian brings laughter to the chemistry classroom. *International Journal of Science Education, 29*(15), 1911–1929.

Williams, I. C. (2012). Graphic medicine: Comics as medical narrative. *Medical Humanities, 38*(1), 21–27.

Zuromskis, C. (2013). *Snapshot photography: The lives of images*. Cambridge, MA: MIT Press.

3

DRAFTING COMICS-BASED RESEARCH

1. CREATIVE THINKING: PLANNING RESEARCH STRATEGY

Researchers are currently beginning to explore the vast potential of using comics in research, including multimodal and sequential methods of data elicitation, collection, analysis, and dissemination. In this chapter, I will propose practical steps needed to carry out a comics-based project. This chapter, and the entirety of this book more generally, is driven by the need to bridge a methodological gap that sees significant developments in the current literature concerning research conducted with visual methods, especially within ethnographic approaches. Although the literature on image-based methods in qualitative research is constantly growing (Cardano & Gariglio, 2022), little attention has been paid to the research steps that precede and follow fieldwork that has adopted a comics-based approach. Specifically, what is recognized to as Comics-Based Research (CBR) refers to an extended set of practices and techniques that uses the sequence of images and texts for the collection, analysis, and dissemination of data within social research. As Ramos (2004) points out, comics allows for the production of a different theoretical and cognitive frame for identifying both the object under investigation and the results produced.

Initially, the development of CBR was limited to a group of scholars/artists united by scientific passion and graphic talent and, therefore, often isolated in their production of knowledge. To date the use of comics represents an emerging promise in social research because of its versatility and integration to existing techniques, laying new epistemological and methodological foundations (Boguslaw, Weiser, Polycarpe, Burns, & Rochlin, 2005). It is no coincidence that prestigious scientific journals such as the *Harvard Educational Review, Annals of Internal Medicine,* and *Qualitative Research* are

increasingly publishing CBR. Using visual materials to facilitate and trigger dialogue through various techniques (Gariglio, 2016, Cardano & Gariglio, 2022; Harper, 2012) can help the researcher manage the discussion and the participant manages any emotional difficulties that may arise. The validation of the use of creative modes to conduct social research (Kara, 2015) has proposed a cognitive leap from what Prosser (2007) called a secondary role to the data collection methods traditionally used within qualitative research. Until recently, using methods based on comics was not considered to align with established conventions. However, today, we can acknowledge the presence of "comics-based" data collection and analysis methods in research as "rich images" (Rose, 2011).

Designing CBR necessitates the initial consideration of constructing an argument to persuade the scientific community of the plausibility of the conclusions reached (Cardano, 2020) while encompassing the deliberate integration of comics from the outset. The formulation of this argument varies in its form and content at different constituent stages of qualitative research. As a result, integrating the comic strip within the research design stages becomes a crucial aspect that should not be overlooked. Developed in the early 1980s as part of a Soft Systems Methodology for information gathering (Checkland, 1981), rich pictures were proposed as a way to represent complex organizational situations using symbols to encapsulate the situation from the point of view of the person drawing and to allow communication about their complexity. In essence, an attempt is made to represent a real situation without censorship, incorporating both factual elements and subjective feelings.

An aspect of particular interest lies in the inherent departure of the comic medium from established conventions pertaining to its form. In planning CBR, I opened the book by including a chapter on the history of comics and some of its definitions, acknowledging the blurred boundaries that often exist when defining what constitutes a comics. Specifically, the definition of comics remains elusive, so much so that graphic novels, webcomics, vignettes, and other graphic-narrative strips are often categorized under the inclusive label of comics. Additionally, the proposed mode of communication exhibits a broad reach, encompassing a range of aspects, with the combination of words and images adapted and molded to strategically meet outlined cognitive objectives.

The comic strip uses words and pictures in a specific manner, in a sort of sequential arrangement, to convey a narrative or content. It is a much broader medium than a particular artistic, narrative, writing style, or genre (comics do not have to be funny). This versatility encourages opening a myriad of possibilities for leveraging comics in social science research. In addition, comics'

wide range of genres, from the graphic essay, to autobiography, to social realism, to pedagogical or countercultural comics, presents vast possibilities for use in formulating research questions. To evaluate the effectiveness of a comic book, we must consider the formal elements of the text itself (author(s), script, drawing technique, style, composition, color) and the paratext, which is the material surrounding the comic book and framing the main text. These components play an important role in a comic book's main goal: successfully communicating a message to an active reader. As we will see in the following sections, it is possible to use comics with multiple meanings spanning the different stages of research. Participants in CBR can be understood as readers when they complete this act of communication with their active participation in the reading process while simultaneously being understood as creators when participating in the construction of data through the graphic realization of a narrative. The use of comics for science dissemination purposes can also be conceived in multiple modes: comics can appear in print and digital formats as newspaper cartoons, comic strips, and one- or multi-page stories within a magazine. The quality of comics within social research is thus closely related to the internal postulates of the research itself, as it is a medium built on the expressive multiplicity of fragments and the synchronicity of possible times.

Echoing debates about the soundness of qualitative methods in general, criticism of the use of image-based methods falls into several categories primarily concerned with the scientific validity of the data collected. In particular, mention is often made of the scientific rigor of the data, their neutrality, reliability, and even transferability from a methodological point of view. In the case of comics, however, a robust ethical component and attention to the emotional involvement of the participants are added. The visual elements of comics add extra value, but this does not diminish the verbal component of the narrative (Clark & Morriss, 2017; Sweetman, 2009). In other words, it is often encouraged to place a visual component alongside a qualitative interview to explore complex themes and bring out a dialogue between the different modes of communication.

Guillemin proposes,

> The use of an integrated approach that involves the use of both visual and word-based research methods offers a way of exploring both the multiplicity and complexity that is the basis of much social research interested in human experience. (2004, p. 273)

Participants' drawings can be used to elicit further verbal data by asking participants to reflect on what they have drawn (Ellis, Hetherington, Lovell, McConaghy, & Viczko, 2013; Silver, 2013). Visual and multimodal methods

are employed by qualitative researchers in many creative ways and in many different contexts, and a range of different terms are used to describe similar techniques. Although desired and celebrated in the qualitative research tradition, this polyphony can be confusing and confounding to those new to the field (Glegg, 2019).

2. GATHERING COMICS-DATA

Cardano tells us in his *Defending Qualitative Research* (2020) that in preparing qualitative research, it is usual to distinguish four distinct phases: (i) planning or design; (ii) data collection; (iii) data analysis; and (iv) textualization (Cardano, 2020). The stage for which the greatest efforts have been made to define "how" the topic should be pursued is that of data collection. In this section, I consider using comics in data collection, spanning across diverse forms and structures. To consider comics as a means of generating data involves reflecting on their integration with traditional techniques, as well as regarding them as autonomous and distinct elements. These differing perspectives over time have engendered heated theoretical debates.

While Ball and Gilligan (2010) agree that visual techniques are often incorporated into research studies and combined with traditional qualitative approaches such as interviews and focus groups, other authors (Kuttner, Weaver-Hightower, & Sousanis, 2021; McCloud, 1994) argue that using comics presupposes the establishment of a new epistemological as well as a methodological paradigm. Although CBR is increasingly used and validated in qualitative research, as part of an increase in creative and visual methods more generally in social science research, their use in data collection is less common (Rainford, 2020). Their use is often more employed in the dissemination of research findings and less aimed at creating a third object (Dumangane, 2020) on which to focus discussions. In addition, comics are increasingly employed in graphic recording or note-taking at scientific conferences (Dean-Coffey, 2013; Rohde, 2013), as well as a new way of presenting research abstracts.

The possibility of producing a graphic artifact, and thus thinking of the comic book as a "third" object, fills the function that Harper (2012) identifies in photos of providing participants with some critical distance on key questions that can develop a new interpretive sense that brings the researcher closer to the participant.

However, unlike photo-elicitation-based techniques, comic strips can provide a greater critical distance for discussing particular issues. In particular,

drawings are used by qualitative researchers in many creative ways and many different contexts that can focus attention on reflections of specific individual experiences through images provided by the researcher or generated by participants. Some authors (Bartlett, 2013; Galman, 2009; McNicol, 2019) have pointed out that the light-hearted and, in some respects, playful nature of comics can more purposefully engage participants while also expanding their potential in generating new research data.

Comics are thus a powerful way to explore the possibilities of communicating using "texts immersed in images" and "images anchored in words," which "convey meaning back and forth across their boundaries" (Sousanis, 2015, p. 53). The atmosphere between researcher and participant is one of mutual understanding and interpretation since using comics does not require being familiar with the underlying visual conventions and having difficulty decoding the message.

Here, I propose different uses of comics and the realization of drawing. First, it is possible to use comics as a form of elicitation. The most classic and recognizable form in social research is photo-elicitation, which has been recognized as valuable for engaging participants and encouraging reflection on issues beyond what can be achieved with traditional interview techniques (Fearon, 2019). In the case of comics, the use of elicitation can be helpful in focusing participants' memories (Fearon, 2019). As Prosser and Loxley (2008, p. 4) put it, visual methods can "slow down observation and encourage deeper and more effective reflection on all things visual and visualisable; and with it (...) reflect more fully the diversity of human experiences."

One of the most commonly employed methods is to present a vignette to participants during qualitative research (e.g., as part of an interview or group discussion) or quantitative research to gather information about their own behaviors. Vignettes usually constitute short stories about someone's experiences or life and are presented to participants by the researcher.

The creation of the vignette can be done in many ways: it is possible to develop the story from previous and already completed research or to create a new story that participants can relate to that tends to reflect the purposes of the research. In administration, asking participants to comment on what they see and think of the dialogues, drawings, and what they would do in the situation shown is possible. In this way, by proposing an item to be displayed, it is possible to address sensitive topics where the participant may not feel comfortable talking about their personal situation and may be hiding the truth about their actions or benefits. In fact, by asking people to comment on what is happening in the vignette, no direct questions are asked of the participant, and the focus is on the third person. From the narrative made, it is, therefore,

possible to make one's own personal experiences merge without making the participants too uncomfortable (Hughes, 1998).

In proposing vignettes, however, it is necessary to keep in mind that the researcher must be familiar with all the structural elements of cartooning, including the arrangement of images, their relationship and association with other images, the creation of visual analogies, the careful use of exaggerations and simplifications, and the choice of expressive postures, gestures, and facial expressions to convey emotions and capture the viewer-reader (Eisner, 1996). All images have in common that they are inherently ambiguous, engaging the viewer in constructing their meaning (Becker, 1995). As Schwartz (1989) notes, this ambiguity is not a disadvantage since the multiple meanings nego- tiated by viewers can trigger discussions and produce rich data. In addition, some types of imagery can reduce the barrier between researchers and par- ticipants (Harper, 2012). It is often the case that the researcher herself draws the vignette. Alternatively, given the many potential pitfalls in designing visu- alizations (Bresciani & Eppler, 2015), collaboration with a professional artist can sometimes develop. In the first case, I show an example from the work of Lucia, an Italian nurse who chose to delve into the intricate subject of com- passion fatigue through the use of vignettes for colleagues to expound upon. Lucia created her vignette (Fig. 3.1) by pairing it with open-ended questions about the interviewee's personal experiences.

As can be visualized from Fig. 3.1, the different panels show some of the activities of a caregiver who, through simple lines, always appears distressed and emotionally distressed. Only in the last panel do the lines disappear, giv- ing way to an apparent closeness between colleagues symbolizing support. The vignette involves the filling in of the participants' thoughts and dialogues. This moment is extremely crucial because it calls for complete cognitive and emotional immersion on the participant's part. In this case, the vignette is an effective tool to reduce emotional distress related to stress that was undoubt- edly exacerbated among healthcare professionals during the pandemic. In this case, filling in with one's own individually oriented impressions offers the researcher an open and critical discussion in a research context (Denney, Case, Metzger, Ivanova, & Asfaw, 2018).

In contrast, when relying on an artist to create the vignette, the interaction with the researcher must be documented and well-established. The goal is not solely making the researcher's request visually comprehensible, nor to pro- duce an artistic work devoid of its narrative significance. The goal is embod- ied in creating a horizon of shared meaning, a fusion of meanings, words, and images reflected in what is created. The interaction process between art- ists and researchers permeates the overall research design, and it is useful

Fig. 3.1. Compassion Fatigue Vignette.

to integrate scientific needs with artistic ones to exploit the medium's full potential. It is, therefore, central that the artist and the researcher (or research team) schedule a series of meetings from the outset, especially if the cartoon represents research that has already been done. In this case, in addition to a general presentation of the research, all materials collected and generated, such as interview transcripts, notes collected in the field, and even scientific insights potentially helpful in understanding the phenomenon under investigation, should be shared. Once the material has been processed, the artist will try to incorporate what has been told and merge it with their vision and

graphic elaboration. In essence, scientific metaphors will be organized into artistic proposals according to a joint selection of the parts. It is essential to consider all elements in the realized table: colors, layout, space distribution, presence of balloon speech or balloon thought, figures moving the scene, possible representations of stereotypes, and also everything that is left out. The composition of the final narrative is subject to continuous adjustments that flow into different meeting moments. Every single scene – every single sketch is therefore not left to chance. Once the panel is created, it will then be presented to the participant.

In making a whole comic strip or a simple vignette, it is first necessary to consider the possibility for the reader/participant to access the inserted codes. Therefore, the "reading" skills of the comics itself, as well as the ability of the researcher and artist to convey the clear concepts in an accessible way, must be weighed. Using elements that are too abstract, not providing adequate support, text that is not accessible to participants, and, more generally, an ill-harmonious integration of visual and textual elements are all elements that can negatively affect participants' reading of the comics. As much as we have seen it to be a usable medium when applied to research, the accessibility of comics may not be obvious. The issue of accessibility means that it is necessary to ensure that those involved can cooperate fully, even through a narration of the experience, often collected in a final semi-structured interview. Guillemin considers this an integrated approach (2004, p. 273) that provides a concise presentation (Kearney & Hyle, 2004, p. 376).

Nevertheless, the researcher, alone or with the assistance of an artist, is not the only one called upon to create vignettes or comics. With increasing enthusiasm, researchers from different disciplines are choosing to have participants draw. As reported by Al-Jawad and Czerwiec (2019), drawing a comic strip allows participants to use symbols and figures that can facilitate the revelation of deeply held beliefs or values. Just as showing a cartoon and asking people to comment on it can provide a "safe space" for the participant's emotionality, asking them to draw someone's story can also foster the richness of data and make participants feel less vulnerable. Especially with sensitive topics, the interviewee may have defensive barriers that reduce the possibility of revealing their true thoughts or feelings, alluding to why speech is, at times, insufficient. By producing a "graphic artifact," the subject can generate a spontaneous and honest response. Drawings and comics are powerful tools for what many authors (Al-Jawad & Czerwiec, 2019; Green, 2013) refer to as "autobiographical honesty." Kearney and Hyle (2004) observed that

> *The drawing process itself seemed to cause the related feelings and emotions to be internally accessed, and therefore more readily available to verbal sharing, even if the feelings or emotions were not clearly a part of the drawing itself. (p. 367)*

Visual methods can also facilitate the communication of painful and difficult experiences (Guillemin, 2004) in a non-threatening way (Ogina, 2012).

To this point of view, Helen Kara (2015) already opened the debate concerning the participant's starting skills. In other words, is it truly necessary to "know how to draw" to take part in such an activity? Based on my experiences and some research (Al-Jawad & Czerwiec, 2019; De Stefano et al., 2023; Green, 2015), the graphic literacy required of participants does not concern stylistic skills or prior experience in the world of comics. On the contrary, the willingness to try their hand at creating visual and verbal sketches that can give voice (and color) to the participants' experiences is stimulated. However, it is important to mention that, unlike other visual media, comics can generate some resistance among participants who often consider themselves unfit or unable to draw. Thus, despite the researcher's efforts, some participants will refuse to proceed (Horstman, Aldiss, Richardson, & Gibson, 2008). Managing a participant's resistance to drawing begins with respecting his or her position: "Researchers should expose themselves to participants' observations and sensitivities to help increase understanding of the possibilities and problems of conducting qualitative interviews" (Clarke, 2006, p. 27). Moreover, it is always important to remember that artistic quality does not matter (Guruge et al., 2015).

I report here on a pilot experience conducted in the School of Medicine in Bologna, where two workshops (2020–2021) were conducted involving 80 students in reading and creating graphic-narrative sequences (Moretti, Scavarda, & Ratti, 2023). Students were asked to think about why they decided to attend medical school. Among other tasks, they were asked, in the panel on the top half of the page, to "draw yourself, as the animal character, in the scene you are recalling," as shown in Fig. 3.2.

In another activity, students were then asked to complete with a verbal narrative their choice to pursue a career in medicine (Fig. 3.3). With this exercise, and thus thanks to the opportunity to express themselves through drawing, students reflected on their professional identity, a key component in the transition from student to professional (Green, 2015).

In research with adults, drawing has been considered a novel way to explore patients' experiences of care, illness, and treatment (Cheung, Saini, & Smith, 2016; Eggleton, Kearns, & Neuwelt, 2017; Guillemin, 2004). Drawing

Fig. 3.2. Myself as an Animal Character.

is also used in research with children, for example, to explore living conditions and self-image (Mitchell, 2006), care and interpersonal relationships (Elde'n, 2012), or children's encounters with the urban environment (Ramioul, Heylighen, Tutenel, et al., 2020). Taking a critical look at the presumed centrality of the child in visual methods in general and in drawing in particular, Mitchell (2006) concludes that drawing methods can be as revealing about adults/researchers as they are about children's drawings.

Brailas (2019) suggests in his research that getting participants to draw requires consideration of several aspects. First, the setting is crucial since a spacious and comfortable place fosters storytelling through images. Another aspect concerns the protection of the participant's privacy also through the reduction of external distractions. While public spaces such as cafes are often used for practical reasons (especially by students for research assignments) despite the annoying background noise and resulting low recording quality (Jacob & Furgerson, 2012), these places are even more unsuitable for conducting interviews with drawings. The process would seem out of place in these locations and can cause stress for the participant and the interviewer. This chapter's last section will be devoted to ethics in CBR.

In all the cases analyzed so far, it is necessary to flank the production or commentary of comics with a descriptive verbal encounter. Undoubtedly, it is crucial to have full access to the subject's interpretations and fully grasp their expressiveness, particularly when asked to drawe; it is vital to conduct a follow-up mini-interview to encourage the participant to reflect on the drawing and explore the topic further.

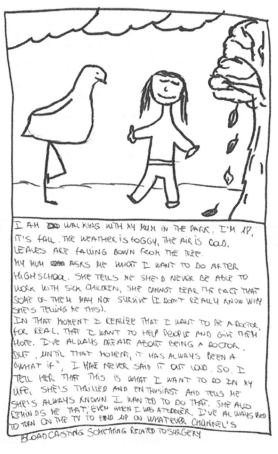

Fig. 3.3. Why I Decided to Study Medicine.

3. ANALYZING COMICS-DATA

This section examines the type of analysis the researcher conducts concerning comics-data. Comics are graphic and verbal narratives co-constructed by the participant and the researcher. Therefore, the type of analysis that we primarily engage in is narrative analysis. Several elements are involved: visual, textual, and narrative. Moreover, analyzing material produced with/about comics means considering, as Cardano (2020) reminds us, several aspects: the way participants use their bodies, the way they handle objects and the agency of objects (cf. Latour, 1993), and all the verbal/nonverbal production that comes to life in the researcher-participant-comics triangulation. Al-Jawad and Czerwiec (2019) also explicitly state that the images analyzed take into consideration channels, colors, and panel sequences, wherein all conveyed thoughts are integral to the distinctive visual language of comics.

From a methodological point of view, and again Cardano (2020) provides an explanation, data analysis can be thought of as a sequence of categorization procedures. We usually start by categorizing aspects of our data one at a time; then, we link the categories applied to our text corpus to observe the relationships between them, resulting in more complex forms of categorization, i.e., some version of taxonomies and typologies. In essence, we do not try to "extract knowledge" from the drawings that have been made. Rather than looking at a "field of inquiry" from the outside, we try to turn to subjective production to learn from the activities in which we are engaged.

When analyzing comics created by the researcher or an artist and shown to participants, the emerging data share many common elements with other qualitative data such as stories and life trajectories. Therefore, the analysis should begin by examining the typical elements of storytelling involving plot, point of view, characters, textual language, and symbolism. For this, the researcher must ask the comic book the right questions about these narrative elements. As Strauss and Corbin (1990) remind us, open coding and the use of questions (questioning about who-, when-, where-, what-, how-, how much-, and why?) coupled with constant comparisons allow investigators to overcome subjectivity and bias. Fragmentation of data forces the examination of preconceived notions and ideas against the data. A researcher may inadvertently place data in a category to which it does not analytically belong, but through systematic comparisons, errors will eventually be detected, and data and concepts will be systematized into appropriate classifications.

Kress (2004, p. 111), in his summary of the fundamental usefulness of visual and textual modes, suggests to us that the experiences that emerge are temporally organized, and data derived from a comics-elicitation are imbued with a certain spatial and temporal quality that allows researchers to the dimensions of space and time in ways that are free of boundaries and constraints (Kress & Van Leeuwen, 2002). The thematic analysis involves identifying themes that emerge from the data (Harding, 2013). The thematic analysis is "a method of identifying, analyzing, and reporting patterns (themes) within data" (Braun & Clarke, 2006, p. 77). Thematic analysis involves searching for repeated patterns of meaning within a data set (Braun & Clarke, 2006). Coding plays an essential role in thematic analysis, as initial coding was necessary to break down the data.

On the other hand, when analyzing comics produced by participants, it is important to consider that what is presented is not just a sequence of visual narratives but the individual's perspective in producing drawings. It will

therefore be necessary to identify and develop a series of themes and frame them in relation to experiences that exist in the subject and are made "visible" through graphic production. For this, and as anticipated in Section 2 of this chapter, the quality of drawings is not relevant (Gravestock, 2010) precisely because of the message presented by words/images. Analyzing participant-produced comic strips presupposes that the researcher brings out unconscious ideas and connections, bringing to the surface the (social) reality that is being told with the storyboards. On a practical level, researchers can group the drawings into different themes and first look at the frequency (how often) these themes emerge (Thomas, 2009).

It is more appropriate to reflect and combine different aspects at a later stage. It is possible to examine the visual, textual, and symbolic aspects of comics by starting with four types of questions:

- **Contextual questions**: how data collected at each time relate to the context.

- **Thematic questions**: these questions are intended to guide the interpretive phase of data analysis.

- **Visual questions**: how visual elements are incorporated and presented.

- **Interacting questions**: how subjects, mediators, and barriers intervene in specific behavior.

These types of questions are useful in creating a "comics-matrix" (I created an example of it below) that can facilitate the researcher in analyzing visual and textual material with respect to participant-produced drawings.

As noted, the analysis of drawings is a complex procedure, capable of illustrating interconnections not only between thematic and visual components but also with respect to the spatial and temporal representation of a certain phenomenon. In a sense, the "logic" of temporal sequence (Kress, 2004, p. 112) typical of other textual and visual expressions are overcome. With comics, visual representations challenge organizational linearity, allowing for a more complete and integrated illustration of the theoretical "meaning-making process" of ideas, emotions, and information without bowing to the demand to prioritize certain elements along a temporal sequence. Images become content capable of externalizing conceptual interiorities of lived realities. Therefore, the process of analysis must also go through an "interpretive validation" of the participant who, through verbal description, will choose, sift, and select the data interpreted by the researcher.

Comics-matrix:

Contextual Questions	Thematic Questions	Visual Questions	Interacting Questions
How do prior life experiences impact the experience of drawing?	How is the narrative organized?	How is the sequence of images organized?	Who are the main characters?
How does the passage of time affect the way participants respond to the researcher's prompts?	Are the words congruent with the images?	Are there predominant colors in the scene?	Are participants honest in their drawings?
What can we understand about the cultural and social context?	Compared to the prompts provided by the researcher, what is left out?	How do the different panels relate to each other?	Does drawing allow participants to express their vulnerability more readily than other mediums?
What is revealed about personal values and life experience?	Are there recurring themes?	What visual metaphors do participants use?	How vulnerable?
What view or perspective on the given subject matter does this drawing present?	Does the response to prompts present dominant cultural narratives?	What is the meaning behind the image?	What does this image tell us about the participant's view of their story?

4. DISSEMINATION AND COMMUNICATION

In this section, I examine the role that comics can play in the dissemination of scientific results. Scientific dissemination is a growing need in research, and in recent years, a number of resources have been invested in using modalities that can reach a broad audience. When discussing dissemination, I refer to the transfer of results to facilitate their exploitation (including economic exploitation) with a view to practical use. In this case, the target audience will be those specialized in a particular field, such as the scientific community or legislators.

On the other hand, communication includes information and promotion activities to increase the visibility of the project and thus targets a more general audience (the public, the media). It, therefore, maybe be more effective to plan an overall strategic framework covering both activities to make the most of available resources. Closely related to each other, dissemination and communication operations allow, respectively, to transfer knowledge to specific target audiences and also to gain visibility with a wider audience.

Over time, researchers have begun to use comics as scientific outputs to showcase, on par with accredited publications in international journals, the leading data that emerged with research. Thus, comics can become a medium for scientific popularization and communication about specific issues. Several authors (Kara, 2015; Labarre, Barnard, & Northfield, 2012; Sousanis, 2015) argue that comics have also become academic products in their own right, capable of reaching a wide audience and stimulating new "scientific knowledge." The type of popularization, involving both online and print publications of comics, aims to reach both a broad, non-expert audience and specific categories and groups at the scientific level. These possibilities have been the focus of recent research (Griffin, 2019; Kuttner et al., 2021) that has emphasized the growing popularity of comics in academia, including Sousanis' (2015) dissertation presented as a graphic novel and Field's (2016) statistics textbook, also based on the graphic novel form. As we will see in Chapter 4, devoted to the social genre of comics, visual narratives are often used extensively within the health field to engage patients in complex issues, both because of their accessibility (Williams & Sarson, 2018) and their ability to encapsulate humor within them (Kennedy, Rogers, Blickem, et al., 2014). This extended use of comics, which benefits from their complexity, is in contrast to the use of comics to increase the accessibility of text, such as their increasing use in the medical field (Green & Myers, 2010).

According to Erin Polgreen, "comic book narratives can work across platforms, engage younger, more visually oriented readers, and transcend cultural boundaries" (2014, p. 12). Polgreen quotes cognitive scientist Neil Cohn: "The evidence is quite clear that sequential images (usually along with text) are an effective teaching tool" (2014, p. 13). Indeed, today it is almost commonplace to say that comics and cartoons are valuable tools for teaching multimodal skills (El Refaie & Hörschelmann, 2010). As Cohn notes,

> *a growing body of research suggests that sequential images combined with text are an effective tool for communication and education (e.g., Nakazawa, 2005; Nalu, 2011; Short, Randolph-Seng, & McKenny, 2013), beyond mere entertainment. (Cohn, 2014)*

Combining the capabilities offered by the visual channel with the verbal structure allows complex ideas to be converted into usable messages that are within everyone's reach. In addition, comics can convey important and complex topics in a more appealing form that can introduce scientific concepts in an engaging, interactive, and playful way (Bartlett, 2013).

One aspect to consider when using comic books created by participants is that it is not only the researcher who needs to know about visual analysis, "Participants also need to develop a critical awareness of visual representations"

(Gubrium & Harper, 2013, p. 35). In line, therefore, with the other phases of research, the preparation of a comic strip for science popularization must also necessarily take into account the graphic and textual literacy of the target audience. Pauwels (2015, p. 108) refers to the "assumption that images are obvious and do not need further processing, framing, or analysis." However, in most cases, this is not true: images may not be easy to interpret, especially for researchers more accustomed to working with verbal interview data. Recipients must understand not only how the comic works but also the message being conveyed. This point depends first and foremost on the type of project one wants to turn into a comic strip. A short project may serve to convey only some basic ones by providing enough knowledge and concepts to frame a phenomenon.

In other cases, the collected stories can be turned into panels exemplifying the protagonists' experiences. As an example, the master thesis of Carolina, a brilliant nurse who wanted to narrate the issue of miscarriage through images that can stimulate empathy and inclusivity while investigating related social strategies that can be adopted to help individuals process the event. After interviewing a number of women who had gone through such an experience, Carolina drafted a storyboard for each story heard, included the participants in choosing the most significant moments to depict, defined vignette by vignette the whole scene so as to report all the details deemed important by the protagonist and draw a story as truthful as possible. Figs. 3.4 and 3.5 represent the story of Aurora (fictional name), a woman who lost her child at 12 weeks. The vignettes show the evolution of the woman's story, from the happiness of her first visits to feeling "missing a piece of herself" after the loss.

Once the short comic was made, Carolina circulated it throughout gynecological offices to provide emotional support, scientific popularization, and usable communication surrounding an incredibly complex and multifaceted topic.

The creation of a comic strip can also be designed to raise community awareness of little-known and challenging topics. I report the case of an experience on body donation to science. Body donation is vital in medical research and education (Saw, 2018). In particular, teaching human anatomy based on cadaver dissection is the basis of medical education worldwide (Kumar & Rahman, 2017). Traditional cadaveric dissection is the most accurate method for learning anatomy during student training and advanced professional education (Chytas et al., 2022). Although new technologies and nonbiological alternatives have been explored in recent years, they still cannot replace cadaveric dissection because they cannot offer the same learning effectiveness (Chytas et al., 2022; Jiang et al., 2020).

However, whole-body donation in Italy is somewhat more complicated than other forms (e.g., organ donation). Some factors may hinder body donation in our country: age, education, religion, culture, personality

Fig. 3.4. When We Were Happy.

characteristics, and personal relationship with death. Another reason is that potential donors are unaware of this possibility; therefore, appropriate information and awareness campaigns are needed (De Caro, Boscolo-Bert, Artico, et al., 2021; Orsini et al., 2021). In this context, with the aim of increasing awareness of the importance of donating one's body, an interdisciplinary team

I became a workaholic to distract myself from the pain,
but I feel like part of me is missing.

/Claudia Argento

Fig. 3.5. Loosing a Part of Myself.

of sociologists, physicians, and artists is conducting an experimental project
at the University of Bologna, introducing comics as a possible tool to share
information on this important and sensitive topic, in order to support medical
education and research. This project is based on a previous pilot experience

with students of the School of Medicine at the University of Bologna (De Stefano et al., 2023), who reflected on the possible use of Graphic Medicine (see Chapter 4) for these specific issues and developed six graphic projects on body donation. As a direct output of these narratives (6 months of notes from fieldwork; 50 interviews), the Institute of Fine Arts is creating a graphic novel that ensures the applicability of the learning outcomes beyond the project. As shown by the plates, different styles and subjects are intended to give voice both to the stories of professionals and family members of donors (Fig. 3.6) and to highlight the exact value of our corporeality (Fig. 3.7).

Fig. 3.6. Body Donors.

Fig. 3.7. Bodies.

In this scenario, the graphic novel is designed to (1) expand students' and experts' narratives through graphic illustrations, showing the importance of medical research; (2) serve as a resource to different scientific communities and others who support and interact with the body-donation topic; and (3) at the same time, the graphic novel will be an additional strategy to increase whole-body donation awareness in Italy since this research also seeks to reach wider non-academic audiences and invite audience engagement.

5. ETHICAL DIMENSION AND PRACTICAL CHALLENGE

In this last section, I open a reflection on the ethical challenges and implications that the researcher may face in implementing a comics-based project. The ethics of the comics-based approach was particularly discussed in a recent

article (Clark, Prosser, & Wiles, 2010) that contextualized the main implications within the existing practices and approaches based on the use of comics in social research. Specifically, the authors discussed the issues associated with the impact on all CBR: informed consent, anonymity and confidentiality, and the dissemination of visual research.

First, we need to understand that participants often feel exceptionally vulnerable and quite possibly resist when asked to draw. Unlike photos or videos, the practice of drawing is something we are not exposed to during our daily lives, especially in adulthood. Therefore, picking up a pencil or holding a brush poses a challenge for most people. We have seen that resistance can be alleviated by reassuring the research participant that artistic skills are not required or even relevant. However, some people may be anxious and uncomfortable with this request, so it is necessary to understand the time it takes to process and become familiar with the medium. This reality can clearly impact the spontaneity of their feelings and the representation that follows. For this, it is necessary to consider that some subjects may not find the maximum expressiveness in the drawing with respect to the stimuli provided. Therefore, the researcher will have to consider these elements already from the very planning of the research.

An additional element to consider concerns the subjects' privacy; not everyone is willing to share their cartoons in a public forum; this should be explicitly discussed and agreed upon before any images are shared outside the classroom, clinic, or interview or are published. Data collection should ensure privacy safeguards that always involve a follow-up time to put in a debriefing. The participant should also be allowed to withdraw at any time without prejudice. Ethical issues necessarily imply acceptance that participating in this collection method will not harm oneself, others, or the researcher.

REFERENCES

Al-Jawad, M., & Czerwiec, M. K. (2019). Comics. In C. M. Klugman & E. G. Lamb (Eds.), *Research methods in health humanities* (online edn). New York: Oxford Academic.

Ball, S., & Gilligan, C. (2010). Visualising migration and social division: Insights from social sciences and the visual arts. *Forum Qualitative Sozialforschung/Forum: Qualitative Social Research*, 11.

Bartlett, R. (2013). Playing with meaning: Using cartoons to disseminate research findings. *Qualitative Research*, 13, 214–227.

Becker, H. (1995). Visual sociology, documentary photography, and photojournalism: It's (almost) all a matter of context. *Visual Sociology*, 10, 5–14.

Boguslaw, J., Weiser, J., Polycarpe, M., Burns, M., & Rochlin, S. (2005). *Part of the Solution: Leveraging Business and Markets for Low-Income People*. Retrieved from https://www.issuelab.org/resource/part-of-the-solution-leveraging-business-and-markets-for-low-income-people.html

Brailas, A. (2019). Psychotherapy in the era of artificial intelligence: Therapist Panoptes. *Homo Virtualis*, 2(1), 68–78.

Braun, V., & Clarke, V. (2006). Using thematic analysis in psychology. *Qualitative Research in Psychology*, 3, 77–101.

Bresciani, S., & Eppler, M. (2015). The pitfalls of visual representations: A review and classification of common errors made while designing and interpreting visualizations. *SAGE Open*, 5.

Cardano, M. (2020). *Defending qualitative research: Design, analysis, and textualization*. London: Routledge.

Cardano, M., & Gariglio, L. (2022). *Metodi qualitativi. Pratiche di ricerca in presenza, a distanza e ibride*. Roma: Carocci.

Checkland, P. (1981). *Systems thinking, systems practice*. London: Wiley.

Cheung, M. M. Y., Saini, B., & Smith, M. (2016). Using drawings to explore patients' perceptions of their illness: A scoping review. *Journal of Multidisciplinary Healthcare*, 2016(9), 631–646.

Chytas, D., Salmas, M., Noussios, G., Paraskevas, G., Protogerou, V., Demesticha, T., & Vassiou, A. (2022). Do virtual dissection tables add benefit to cadaver-based anatomy education? An evaluation. *Morphologie*, 107(356), 1–5.

Clark, A., & Morriss, L. (2017). The use of visual methodologies in social work research over the last decade: A narrative review and some questions for the future. *Qualitative Social Work*, 16(1), 29–43. doi:10.1177/1473325015601205

Clark, A., Prosser, J., & Wiles, R. (2010). Ethical issues in image-based research. *Arts & Health: An International Journal for Research, Policy and Practice*, 2(1), 81–93.

Clarke, A. (2006). Qualitative interviewing: Encountering ethical issues and challenges. *Nurse Researcher*, 13(4), 19–29.

Cohn, N. (2014). Building a better 'Comic Theory': Shortcomings of theoretical research on comics and how to overcome them. *Studies in Comics*, 5(1), 57–75.

De Caro, R., Boscolo-Bert, R., Artico, M., et al. (2021). The Italian law on body donation: A position paper of the Italian College of Anatomists. *Annals of Anatomy, 238*, 151761.

De Stefano, A., Rusciano, I., Moretti, V., Scavarda, A., Green, M. J., Wall, S., & Ratti, S. (2023, March). Graphic medicine meets human anatomy: The potential role of comics in raising whole body donation awareness in Italy and beyond. A pilot study. *Anatomical Sciences Education, 16*(2), 209–223. doi: 10.1002/ase.2232. Epub 2022 Dec 7. PMID: 36346170.

Dean-Coffey, J. (2013). Graphic recording. *New Directions for Evaluation, 140*, 47–67.

Denney, M., Case, P., Metzger, A., Ivanova, M., & Asfaw, A. (2018). Power in participatory processes: Reflections from multi-stakeholder workshops in the Horn of Africa. *Sustainability Sci-ence, 13*, 879–893.

Dumangane, C. (2020). Cufflinks, photos and YouTube: The benefits of third object prompts when researching race and discrimination in elite higher education. *Qualitative Research*, Epub ahead of print 6 December 2020.

Eggleton, K., Kearns, R., & Neuwelt, P. (2017). Being patient, being vulnerable: Exploring experiences of general practice waiting rooms through elicited drawings. *Social & Cultural Geography, 18*(7), 971–993.

Eisner, W. (1996). *Graphic storytelling and visual narrative.* New York: Poorhouse Press.

El Refaie, & Hörschelmann. (2010). Young people's readings of a political cartoon and the concept of multimodal literacy. *Discourse: Studies in the Cultural Politics of Education*, 195–207.

Elde'n, S. (2012). Inviting the messy: Drawing methods and children's voices. *Childhood, 20*(1), 66–81.

Ellis, J., Hetherington, R., Lovell, J., McConaghy, M., & Viczko, M. (2013). Draw me a picture, tell me a story: Evoking memory and supporting analysis through pre-interview drawing activities. *Alberta Journal of Educational Research, 58*(4), 488–508.

Fearon, K. (2019). 'Have you ever talked to any women with Turner syndrome?' Using universal design and photo elicitation interviews in research with women with mild cognitive impairment. *Methodological Innovations, 12*(2), 1–11.

Field, A. (2016). *An adventure in statistics: The reality enigma.* London: Sage.

Galman, S. A. C. (2009). The truthful messenger: Visual methods and representation in qualitative research in education. *Qualitative Research*, 9(2), 197–217.

Gariglio, L. (2016). Photo-elicitation in prison ethnography: Breaking the ice in the field and unpacking prison officers' use of force. *Crime, Media, Culture*, 12(3), 367–379.

Glegg, S. M. N. (2019). Facilitating interviews in qualitative research with visual tools: A typology. *Qualitative Health Research*, 29(2), 301–310.

Gravestock, H. M. (2010). Embodying understanding: Drawing as research in sport and exercise. *Qualitative Research in Sport and Exercise*, 2(2), 196–208.

Green, M. J. (2013). Teaching with comics: A course for fourth-year medical students. *Journal of Medical Humanities*, 34, 471–476.

Green, M. J. (2015). Comics and medicine: Peering into the process of professional identity formation. *Academic Medicine*, 90(6), 774–779.

Green, M. J., & Myers, K. R. (2010). Graphic medicine: Use of comics in medical education and patient care. *BMJ: British Medical Journal*, 340(7746) (March), 574–577.

Griffin, S. (2019). Comics and visual biography: Sequential art in social research. *Visual Studies*.

Gubrium, A., & Harper, K. (2013). *Participatory visual and digital methods*. Walnut Creek CA: Left Coast Press.

Guillemin, M. (2004). Understanding illness: Using drawings as a research method. *Qualitative Health Research*, 14(2), 272–289.

Guruge, S., Hynie, M., Shakya, Y., Akbari, A., Htoo, S., & Abiyo, S. (2015). Refugee youth and migration: Using arts-informed research to understand changes in their roles and responsibilities. *Forum Qualitative Sozialforschung/Forum: Qualitative Social Research*, 16(3).

Harding, J. (2013). *Qualitative data analysis from start to finish*. London: Sage.

Harper, D. (2012). *Visual sociology*. London: Routledge.

Horstman, M., Aldiss, S., Richardson, A., & Gibson, F. (2008). Methodological issues when using the draw and write technique with children aged 6 to 12 years. *Qualitative Health Research*, 18(7), 1001–1011.

Hughes, R. (1998). Using vignettes in qualitative research. *Sociology of Health and Illness*, 20(3), 381–400.

Jacob, S. A., & Furgerson, S. P. (2012). Writing interview protocols and conducting interviews: Tips for students new to the field of qualitative research. *The Qualitative Report*, 17(42), 1–10.

Jiang, J., Zhang, M., Meng, H., Cui, X., Yang, Y., Yuan, L., ... Zhang, L. (2020). Demographic and motivational factors affecting the whole-body donation programme in Nanjing, China: A cross-sectional survey. *BMJ Open*, 10, e035539.

Kara, H. (2015). *Creative research methods in the social sciences: A practical guide*. Bristol: Policy Press.

Kearney, K. S., & Hyle, A. E. (2004). Drawing out emotions: The use of participant-produced drawings in qualitative inquiry. *Qualitative Research*, 4(3), 361–382.

Kennedy, A., Rogers, A., Blickem, C., Daker-White, G., & Bowen, R (2014, February 8). Developing cartoons for long-term condition self-management information. *BMC Health Services Research*, 14(1), 60. doi: 10.1186/1472-6963-14-60. PMID: 24507692; PMCID: PMC3945740

Klugman, C. M., & Lamb, E. G. (Eds.). (2019, August 1). Comics. In C. M. Klugman & E. G. Lamb (Eds.), *Research methods in health humanities* (online ed). New York, NY: Oxford Academic.

Kress, G. (2004). Reading images: Multimodality, representation and new media. Paper presented at the Expert Forum for Knowledge Presentation, Chicago, IL.

Kress, G. R., & Van Leeuwen, T. (2002). *Multimodal discourse: The modes and media of contemporary communication*. London: Edward Arnold.

Kumar, N., & Rahman, E. (2017). Effectiveness of teaching facial anatomy through cadaver dissection on aesthetic physicians' knowledge. *Advances in Medical Education and Practice*, 8, 475–480.

Kuttner, P. J., Weaver-Hightower, M. B., & Sousanis, N. (2021). Comics-based research: The affordances of comics for research across disciplines. *Qualitative Research*, 21(2), 195–214.

Labarre, N., Barnard, R., & Northfield, G. (2012). Redrawing the page: Reinterpretation, recreation, refinement. *Studies in Comics*, 3(2) (December), 371–379.

Latour, B. (1993). Ethnography of a 'high-tech' case: About Aramis. In P. Lemonnier (Ed.), *Technological choices: Transformation in material cultures since the neolithic* (pp. 372–398). London: Routledge.

McCloud, S. (1994). *Understanding comics: The invisible art.* New York: Harper Perennial.

McNicol, S. (2019). Using participant-created comics as a research method. *Qualitative Research Journal, 19*(3), 236–247.

Mitchell, L. M. (2006). Child-centered? thinking critically about children's drawings as a visual research method. *Visual Anthropology Review, 22*(1), 60–73.

Moretti, V., Scavarda, A., & Ratti, S. (2023). Il fumetto nella formazione medica. Il caso della Scuola di Medicina e Chirurgia di Bologna. *Salute e Società, XXII 2, 129,* 139.

Nakazawa, J. (2005). Development of manga (comic book) literacy in children. In D. Shwalb, J. Nakazawa, & B. Shwalb (Eds.), *Applied developmental psychology: Theory, practice, and research from Japan* (pp. 23–42). Greenwich: Information Age Publishing.

Nalu, A. (2011). Comics as a cognitive training medium for expert decision making. *Proceedings of the Human Factors and Ergonomics Society Annual Meeting, 55,* 2123–2127.

Ogina, T. A. (2012). The use of drawings to facilitate interviews with orphaned children in Mpumalanga province, South Africa. *South African Journal of Education, 32*(4), 428–440.

Orsini, E., Quaranta, M., Ratti, S., Mariani, G. A., Mongiorgi, S., Billi, A. M., & Manzoli, L. (2021). The whole body donation program at the university of Bologna: A report based on the experience of one of the oldest university in Western world. *Annals of Anatomy, 234,* 151660.

Pauwels, L. (2015). 'Participatory' visual research revisited: A critical-constructive assessment of epistemological, methodological and social activist tenets. *Ethnography, 16*(1), 95–117.

Polgreen, E. (2014). The core of story. *The Promise of Comics Journalism. Nieman Reports Spring, 68*(2), 12.

Prosser, J. (2007). Visual methods and the visual culture of schools. *Visual Studies, 22*(1), 13–30.

Prosser, J., & Loxley, A. (2008). Introducing visual methods. *Review Paper NCRM/010*. ESRC National Centre for Research Methods. University of Southampton, England.

Rainford, J. (2020). Confidence and the effectiveness of creative methods in qualitative interviews with adults. *International Journal of Social Research Methodology*, 23(1), 109–122.

Ramioul, C., Heylighen, A., Tutenel, P., Rutenel, C., Tutenel, P., Heylighen, A., ... Dong, H (2020). Reflections on methods for exploring children's encounter with the urban environment. In P. Langdon (Ed.), *Designing for inclusion: Inclusive design: Looking towards the future* (pp. 107–114). Cham: Springer International Publishing.

Ramos, M. J. (2004). *Drawing the lines. The limitations of intercultural ekphrasis*, London: Routledge.

Rohde, M. (2013). *The sketchnote handbook*. San Francisco, CA: Peachpit Press.

Rose, G. (2011). *Visual methodologies*. London: Sage.

Saw, A. (2018). A new approach to body donation for medical education: The silent mentor programme. *Malaysian Orthopaedic Journal*, 12, 68–72.

Schwartz, D. (1989). Visual ethnography: Using photography in qualitative research. *Qualitative Sociology*, 12, 119–154.

Short, J., Randolph-Seng, B., & McKenny, A. (2013). Graphic presentation: An empirical examination of the graphic novel approach to communicate business concepts. *Business Communication Quarterly*, 76, 273–303.

Silver, J. (2013). Visual methods. In C. Willig (Ed.), *Introducing qualitative research in psychology* (3rd ed., pp. 207–221). McGraw Hill Education, Open University Press.

Sousanis, N. (2015). *Unflattening*. Cambridge: Harvard University Press.

Strauss, A., & Corbin, J. (1990). *Basics of qualitative research: Grounded theory procedures and techniques*. Newbury Park, CA: Sage.

Sweetman, P. (2009). Revealing habitus, illuminating practice: Bourdieu, photography and visual methods. *The Sociological Review*, 57(3), 491–511.

Thomas, M. E. (2009). *Auto-photography*. Columbus, OH: The Ohio State University.

Williams, O., & Sarson, J. (2018). *The weight of expectation*. Leicester: AWL.

4

THE SOCIAL GENRES OF COMICS

1. GENRES IN COMICS

The communicative articulation of comics is far from homogeneous. As with other media (print, film, and literature), comic books are distinguished by the themes addressed, the types of characters put forth, and the type of audience to which the comic book is aimed. This set of elements is called a genre. There are endless ways to classify different graphic novels; there are as many genres and subgenres as traditional fiction and nonfiction. The world of comics has become immense, between youth comics, historical or humorous, graphic novels or manga – it is a vast and dynamic art with a bright future ahead.

Historically, comics originated as a phenomenon of social satire or as a form of entertainment for children, but soon the phenomenon interested an ever-widening audience of curious and enthusiastic readers seeking new and original comic books. The gradual broadening of the readership and the massive production of comics, especially since World War II, has realized a diversification of genres, matched by a variety of styles and illustrations. The following are just a few of the most popular categories. Among the many genres, I must start by mentioning the "superhero story," probably the best-known and most popular form of comics that has transformed what were once short episodic adventures into epic sagas. Originating in the United States, this genre is characterized by featuring a man with exceptional powers and abilities who possesses fantastic armor or tools. The strength of this type of comics lies not only in the illustrations and dialogue but notably in the protagonist's personality, which must be convincing and charismatic – as exemplified by Superman (1938) as the progenitor, establishing this archetype. A few mainstream publishers, including Marvel and DC, dominate this genre.

In the late 1940s, horror comics also peaked by presenting dark stories with disturbing overtones, often animated by monstrous or semi-living characters (zombies). They incorporated elements from detective and thriller comics that served as forerunners, and in which progressively more horror undertones were introduced. With the underground revolution, we saw the emergence of a new genre (comix) that uses mainly alternative means of production and dissemination to mainstream channels. The authors strongly criticize contemporary society and some conservative currents, telling stories about drugs, depression, nontraditional sexuality, and, in general, all issues that the industry giants do not publish.

With respect to the genres present, I can certainly also name the romance genre that originated immediately after World War II to cater to an adult and young adult audience. Typically, these stories feature dramatic scripts and portray an urban or rural scenario contemporary to their time of publication.

When discussing genre, it is crucial to acknowledge the intricate landscape of manga, but this requires some clarification. The word manga in Japanese generally denotes all comics, regardless of a target audience, themes, or nationality of origin. However, in the United States, the word has taken on the value of a specific style, characterized by a well-defined graphic line and stories focused almost exclusively on the emotions experienced by various characters. These are often sentimental and adolescent stories set in high schools (shōjo manga). In some cases, manga repurposes the world of science fiction with futuristic stories that include space travel and advanced technologies.

A final genre that is mentioned concerns personal narratives, often referred to as "Perzines." The word Perzine is a genre of zines concerning personal thoughts, stories, or experiences that can take on a confessional nature. Perzines are thus stories that, from the author's personal experiences, opinions, and observations, tell about various topics of interest or interactions.

This brief and certainly not exhaustive list of genres serves as a prelude to framing some of what I have termed as social genres, which will be examined in the following paragraphs. In essence, the genre of comics does not only go by graphic, communicative, and thematic style, but we can also frame it by its social relevance.

As we have seen through the previous pages, the functions of comics are many. It is possible to increase literacy and understanding of complex issues (Hutchinson, 1949), promote sociological creativity (Cary, 2004), understand different social and cultural values (Bitz, 2010; Ravelo, 2013), and develop critical thinking. It is worth noting that these functions are made possible precisely because of the possibilities offered by comics to convey images about reality through language (visual and verbal) that is symbolic, fictional,

or entirely truthful. When used as a vehicle of communication, and thanks to their iconic representations and visual metaphors, comics can convey compelling social messages. Reading and appreciating comics thus becomes a means not only to increase multilingual skills (Winch, Ross Johnston, March, Ljungdahl, & Holliday, 2010) but also to learn about a given society, its values, norms, and nuances. Genres thus become a powerful social catalyst for disseminating social issues through comics.

Nicolas Labarre, through his *Understanding Genres in Comics* (2020), offers an unprecedented survey of the characteristics of numerous currents in comics. Starting by analyzing the concept of genre through a lens borrowed from film studies, Labarre shows that although the term is amorphous, a genre can be understood as a project, a label, and even a contract with the reader. The book is not overly concerned with examining specific types of comics genres; rather, the concept of genre itself is addressed.

Thus, understanding the function of genre within a given social context gives us insight into how much comics can evolve in the relevant era.

This effort was already presented by Duncan and Smith, who, in their celebrated text, *The Power of Comics* (2009), turn particular attention to the role of superheroes and historical memories in shedding light on the conventions present in a given social context. For authors, genres constitute historically stable shared characteristics that, through characters, settings, themes addressed, and narrative patterns, form the basis of a taxonomy shared between creators and publishers. The genre thus functions as a kind of catalog in which to find "entries" that contain different characteristics by which it is possible to trace the contextual elements in which the entry/comic book was produced and its social mission. The genre functions as a useful model for navigating through complex social phenomena that are made not only accessible but also understandable to a broad audience through the usability of images.

In *Reading Graphic Novels, Genre and Narration* (2016), Achim Hescher suggests that in comic studies, the word "genre" takes on a circular meaning that includes an assemblage of multiple elements, including discourses, texts, and images. It thus becomes an actual social product.

In general, media theorists (Jauss, 1982) point out that genre has great utility as a "guide to consumption" and horizon of expectations experienced by the audience. It is, therefore, possible to introduce new narrative patterns and shape the reader's own experience by acting on cognitive and emotional levels.

In the following sections, I will therefore address the *social genres* of comics with reference to their specific features, their cultural and economic configuration, the themes they address, and the context in which they are produced

and read. Again, the list I will present cannot be exhaustive since the topics of social interest are multiple and complex. However, I will try to provide some perspectives that have encapsulated comic in their narratives, giving rise to new social genres in comics studies.

2. WHEN COMICS MEET HEALTH: GRAPHIC MEDICINE

As the first social genre, I examine the use of comics within the complex world of health, analyzing, in particular, the Graphic Medicine (GM) approach.

GM is an emerging field of study with several areas of interest. Trying to define it, we can recall the definition provided by its creator Ian Williams, who identifies it, within the evocative *Graphic Medicine Manifesto*, as the intersection between image and health, the connection between comics and the dimension of healthcare. GM begins to gain recognition inside and outside the academy. On the official website (http://www.graphicmedicine.org/), there is a regularly updated database of the various graphic novels on the market; many of these works are drawn and packaged by skilled cartoonists who have had personal experience with the disease or have cared for a relative with health problems. Specifically, the international GM movement is a group of physicians, nurses, academics, caregivers, writers, artists, and cartoonists who are developing alternative ways of using comics in health care to provide information, tell stories (both from the perspective of patients and health care providers), and teach medical humanities to future physicians and nurses. It should be noted that the use of comics to depict and describe medicine is certainly not new. Hansen (2004) points out that already in the 1940s, medical figures occupied a prominent place in various adventure comics, to the extent that they likened medical discoveries to heroic and valiant acts and the realm of medicine to a battlefield, which immediately leads us to a comparison with what happened to the medical category during the COVID-19 pandemic, in which the power of metaphors and symbols was enlivened more by literature than by science.

As an accessible medium for patient education and public awareness in a broader sense, GM can be used to raise awareness about barriers to social inclusion of people with disabilities (Manohar, 2022), living with heart disease (Swanson, 2016) and the effects of the COVID-19 pandemic (Mirza, 2021). In addition, recent studies recognize the use of GM as effective in science education to improve the understanding of clinical concepts (Hoffman, 2021) and thematic topics considered taboo, such as death and bodies dissection (De Stefano et al 2023).

Coupled with this, the use of comics can have an impact in reducing the stigma of certain disabilities, socialize patients and their caregivers to manage certain diseases and inform and promote greater empathy among healthcare professionals and medical students. This quality is particularly resonant in comics dealing with invisible illnesses (mental disorders), where colors and shapes can make the illness perceptible by creating images of the condition experienced. The iconography of illness can also help change public perception of pain. Comics written by and around vulnerable groups can provide valuable information about the daily struggles and challenges individuals face. In a way, comics can act as a soundboard giving a voice to marginalized groups.

From a methodological point of view, graphic disease narratives can be used predominantly for interactive use (Gariglio, 2010), i.e., as an element mediating interaction between researcher and observed, in two meanings: as a stimulus for investigating participants' reactions and as an element produced by the participants themselves. It must be made clear that these are synthetic images executed by the human hand, not analogue images, such as photographic images (Sorlin, 2001).

Below is an example from Brian Fies' award-winning *Mom's Cancer*, which tells the (real) story of a mother diagnosed with metastatic lung cancer. In addition to being the author of the comics, Brian is also this woman's son, and he describes with cartoons how a serious illness affects the patient and the family, practically and emotionally. However, what the medium of comics succeeds in doing, unlike other channels, is to make the reader discover the "unspoken," as well as the dialogues that take shape. Indeed, in Fig. 4.1, the dialogue between the woman and the doctor (presented in classic speech balloons) is illustrated while the boxes illustrate what the woman is actually thinking. As can be seen, the woman feels a great deal of discomfort caused by the doctor's continuous smiling, creating more anxiety than reassuring the patient. The possibility offered by comic strips to visualize thoughts can contribute significantly to training health professionals by looking at underlying dynamics at play during therapeutic encounters.

In recent decades, numerous international studies, conducted both in the United States and in Europe, have shown that humanistic and social disciplines have been increasingly included within the academic curricula of medical schools, alongside the more traditional clinical and biological disciplines (see, e.g., Ousager & Johannessen, 2010). Since the 1980s, as a result of the changes that have taken place within the healthcare environment – including the change in clinical decision-making, which is more oriented toward an evidence-based approach, the transformation of the role of patients from

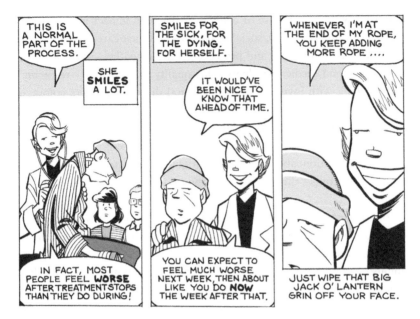

Fig. 4.1. Mom's Cancer.

passive subjects to increasingly active and collaborative actors in the thera-
peutic process – future physicians are called upon to display specific emotional
and relational competences (Vinson & Underman 2020) for the development
of which innovative or creative teaching methods prove to be particularly
useful. These are skills suitable for handling interactions with patients and
based primarily on building trust and understanding the experiences of others.

Another example of how images can intervene in supporting the narrative
is provided by the graphic novel *When David Lost His Voice*, written and
illustrated by Judith Vanistendael and translated by Nora Mahony. It tells the
story of cancer and how this diagnosis affects not only the person involved
but also the whole family. Words for David have never been his strong point,
and he would rather keep silent about his illness, pain, and the end that awaits
him, much to the frustration of his wife, progressively consumed by the loom-
ing shadow of death, and his daughters, who struggle to be as helpful as
possible. Due to the inability to tell his story produced by the laryngectomy,
David writes a message to his daughter, who will keep it so as not to lose her
father's words (Fig. 4.2).

As these images show, comics and graphic novels can be used to convey ill-
ness narratives that combine text and images, fitting in with Narrative Based
Medicine (Moretti & Scavarda, 2021) as an innovative element that allows

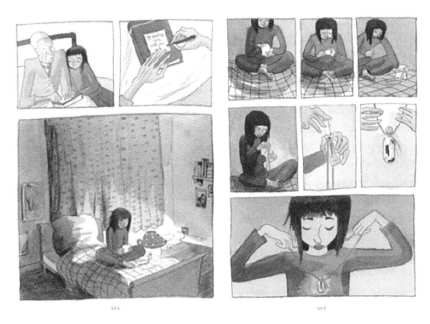

Fig. 4.2. When David Lost His Voice – Keeping His Father's Message.

access to visceral and often difficult-to-communicate contents of the subjective experience of illness.

The accessibility of graphic novels and the possibility of addressing sensitive and taboo topics with irony or rhetorical devices make them an effective dissemination and social communication tool for people with different abilities (e.g., cognitive disabilities or mental distress). The so-called vulnerable individuals, therefore, can be actively involved in redefining the social representations they are subjected to by conveying counter-narratives that restore dignity to their suffering and highlight the barriers inhibiting their full social participation.

Reflexivity, self-awareness, and clinical empathy – the latter understood as a set of interactive skills aimed at understanding the patient's needs and processing one's own and others' emotional experiences (Vinson & Underman 2020) – are just some of the skills required of medical school students, especially in the United States, but increasingly also in European countries (Hatem & Ferrara 2001). In this context, the use of "pathographies" as didactic tools can be functional, on the one hand, to gain a more appropriate and emotionally engaging understanding of the patients' or caregivers' point of view (Green, 2013) and, on the other hand, to develop a reflection on socialization to the future professional role (Green & Myers, 2010). "Becoming a

professional" implies a transitional process that pre-empts the internalization of the professional identity and can be facilitated by both individual and collective creative activities (Monrouxe, Rees, & Hu, 2011).

As such, for about a decade now, medical teachers have integrated graphic tools into the curricula through the use of sequences of graphic narratives within disciplinary courses or through the organization of workshops dedicated to the use of comics in healthcare (Green, 2015). These workshops, particularly popular in the UK and the USA, often involve two types of activities: (1) the reading and discussion of comics and (2) the creation of comic strips to share specific experiences or emotions (Maatman, Minshew, & Braun, 2022). The ability to transport the reader into the story, which is inherent to comic strips, fosters the development of empathy (Tsao & Yu, 2016), even in the clinical sense. Furthermore, the combination of text and images enables the development of analytical and creative thinking, which are useful in learning and socialization processes (Green & Myers 2010). Although GM is now a more established field of study internationally, studies aimed at evaluating the effectiveness of graphic narratives as educational tools in the medical field are still limited (see, e.g., Anand, Kishore, Ingle, & Grover, 2018; Green, 2015) especially in Italy (Moretti, Scavarda, & Ratti, 2023; Moretti & Scavarda, 2021). Initiatives are often fragmented and experimental, but they are also beginning to emerge in our country to enable students in training to improve observation and diagnosis skills, develop problem-solving skills, and explore with a critical eye the medical-health reality and their own training experiences (Girotti, 2016).

3. A GRAPHIC JOURNEY OF MIGRATION

The production of comics dealing with the topic of migration is flourishing. Graphic memoirs, autobiographies, graphic journalism, and ethno-graphic novels – to name but a few genres – have given rise to a great deal of attention to past and contemporary international migration experiences. As we will see in this section, comics have a front-row seat in promoting a different image of migration and migrants themselves, expanding a debate that has shaped and filled the agendas and policies of many governments in recent years. Therefore, this second social genre will focus on the production of comics dealing with the complex and sensitive topic of migration. Several examples will be illustrated on how comics represent the various protagonists, proposing a narrative that can offer a different social and legal understanding of the phenomenon, overcoming, in fact, the dichotomy on the acceptance/rejection of

migrants. Recent studies have approached the topic from different perspectives. In particular, mention may be made of the memory collection and representation of the migrant experience edited by Serrano (2021). Notably, within an anthology of migration comics called *Immigrants and Comics Graphic Spaces of Remembrance, Transaction, and Mimesis* (2021), a group of artists and transdisciplinary scholars examine the migrant experience by looking not only at different geo-political contexts but also by highlighting the social and cultural environment in which comics were produced. In essence, attention is also sought to focus on the type of message conveyed by comics and how the theme of migration was an indispensable and vital topic in the development of the comic medium in the twentieth century.

Comics about migrations have indeed been shaped across languages, cultures, and time by the diverse socio-political stances; at the same time, from depicting the political and social understanding of migration, comics are tools that might be used to propose acceptance or rejection of migrants. In this regard, comics are far from being static. With panel sequences, pages flip, presenting different possibilities of reading them (asynchronous, synchronous, paying attention to the images first and then to the words and vice versa), comics are dynamic, fluid, and in constant negotiation with the topic. Simple techniques can be put to complex use: the construction of space in a sequence can be relevant to present the traumatic experience of the migration journey visually; colors or lack thereof might represent feelings (fear, hope, desperation) of migrants once in the new place; thought bubbles can express hurtful memories; speech bubbles can show the frustration of not knowing the local language. Other comics might be key to tackling some of the mental health challenges of migration. Moreover, as explained by Kate Evan in her book *Threads from the Refugee Crisis*, comics can express the stories of the "people who don't count."

Mark McKinney (2021), in his *Postcolonialism and Migration in French Comics*, presents comics from the formal dismantling of the French colonial empire in 1962 up to the present. French cartoonists of ethnic minority and immigrant heritage are a major focus, including Zeina Abirached (Lebanon), Yvan Alagbé (Benin), Baru (Italy), Enki Bilal (former Yugoslavia), Farid Boudjellal (Algeria and Armenia), José Jover (Spain), Larbi Mechkour (Algeria), and Roland Monpierre (Guadeloupe). The author focuses on these comics precisely because they represent different perspectives on postcolonial minorities often left in the shadows by dominant narratives. The themes presented are varied and follow the pen of its main author, who chooses to depict, in the different chapters that make up the work, scenes in the life of a migrant, from the lack of documents, subtle everyday racism, the strenuous defense of one's home, and a violent rejection toward political impositions.

In relation to this, I would like to mention the work of Yoshitaka Kiyama and his *The Four Immigrants Manga* work created between 1924 and 1927 in the form of 52 "episodes." The manga tells the story of Kiyama and his three friends as immigrant students from Japan in San Francisco in 1924, a historical moment when immigration laws particularly hardened, and many Japanese, including some of the protagonists, chose to leave the United States because of this. The various episodes thus recount the misadventures, worries, and hopes of four young students in a foreign country.

Graphically narrating migration thus means imposing itself in the public debate, trying to patch up hostilities and prejudices that often pervade modern society. Among the main goals underlying a dense artistic production with a migrant theme, the desire to level stigma and prejudices, even strongly manifested ones, certainly stand out. By offering counter-narratives, it is possible in this sense to learn from and empathize with the stories of others, visualizing what have often been traumatic and unsettling changes that have occurred in the lives of migrants. Migration experiences do not end with the subject's arrival within the new context, as the sociological tradition teaches us in Alfred Schutz's two essays, *The Stranger: An Essay in Social Psychology* (1944) and *The Homecomer* (1945). A sense of foreignness pervades the subjects when they land in an unfamiliar context when they know they will have to be accepted or, at the very least, tolerated by the community they encounter. This reality is why the "crisis" or "trauma" is experienced by the newcomer upon insertion into the new community since the subject does not know how to decode or penetrate the cultural model of the community because it is a model that does not belong to him, distant from that of which he is the expression and bearer. As Georg Simmel (1908) also reminds us, the foreigner is "the one who arrives today and will remain tomorrow."

It is, therefore, crucial to also focus on the narratives that show the experiences of arriving in a foreign country.

In this regard, the project/work *The Most Costly Journey* is worth mentioning, a comic book anthology that presents stories of survival and healing. The stories are told by Latino immigrant farmworkers settled in Vermont and drawn by New England cartoonists. The initiative that this work aims to address is the often-overlooked mental health needs of vulnerable immigrants.

In Fig. 4.3, you can see the loneliness and melancholy of the migrant who feels homesickness for home and his life and, at the same time, the joy of getting a driver's license, a symbol of autonomy and integration in the new context.

Author Nabizadeh explores in her work *Representation and Memory in Graphic Novels* (2019) the role of ethics and empathy in the processing of

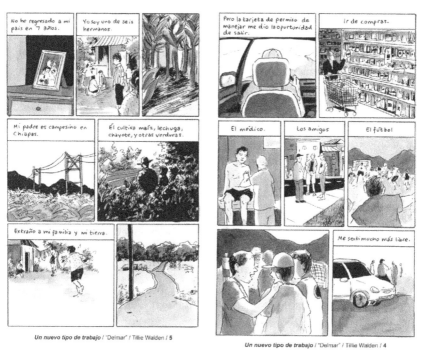

Fig. 4.3. **The Most Costly Journey.**

"grievability," a concept widely addressed by Judith Butler (2009). In essence, Butler links the cultural conditions of a certain context's access to the dignity of mourning to the prior valorization of lives: "a life that has no dignity of mourning [ungrievable] is one that cannot be regretted because it never lived, that is, because it never counted as a life." In this sense, the dignity of mourning is an attribute of lives that count. A bereavement to be worthy must deprive the life of someone of worth. This is why various discursive devices and political practices distinguish populations between those that pose a "threat to human life" and "living populations in need of protection." Nabizadeh thus seeks to propose a narrative aimed at redeveloping the lives, and the value attached to them, of all types of migrants.

Artist Safdar Ahmed, across a range of mediums, including drawing, graphic narratives, painting, musical performance, and installation, seeks to bring attention to those lives that would otherwise remain unrecognized by the media. In his comic strip *Still Alive* (2021), Ahmed seeks to raise awareness about Australian immigration policies and his lived experiences of indefinite detention. Through the boards, Ahmed demonstrates how comics can be a sophisticated medium of storytelling, self-reflexivity, and reportage.

The book is deeply ethical in that it focuses on the testimonies of people stripped of their humanity by the state. Alongside narrating their complex stories, the author directly includes artistic artifacts created by a vulnerable population.

The work of many contemporary cartoonists is oriented precisely toward the desire to generate alternative archives of memory through their works, in which the figurations of the other are imagined, restrained, and "animated" through the boards and interstices of the page.

Comics thus becomes a politically relevant and socially revolutionary medium of inquiry. By generating different imaginaries and recreating verisimilar scenarios, the artists invite the reader to reformulate his or her subjectivity and challenge discursive iterations and pre-established cognitive patterns. Thus, the counter-narratives presented through comics do not unfold in a few bombastic scenes; instead, they address the common, everyday difficulties of those seeking to assert their agency and build a new status for themselves. "The narrative is not just a structure of meanings but also an act that engages and seeks to influence its audience's understanding, emotions, and ethics," as well as that the beginning of a narrative, like that of a speech, is essential for this purpose (Phelan, 2008, p. 195).

A crucial role is in the narration of trauma through comics, evident in the work *Documenting Trauma in Comics* (2020) by Davies and Rifkind. According to the authors, comics have significantly refined esthetic models of trauma narratives. Cultural acceptance of "trauma storytelling" was probably sealed with the publication of Maus, which actively produced theorizing about the experiential qualities of trauma to the extent that it generated significant shifts in research and academic activity as well. In this comics, the story binds to the trauma in a symbiotic and mutually constitutive relationship in which it no longer understands where one begins and the other ends.

It is essential to note that comics on refugee experiences are not new. However, following tragic events, there has been a heightened interest in graphic productions dealing with the experiences of migrants and, in particular, that of refugees and asylum seekers. It is worth mentioning that since the beginning of the civil war in Syria, global media attention to cultural productions, including comics, that chronicle forced migration has increased. In *The Unwanted: Stories of the Syrian Refugees* (2018), American author and illustrator Don Brown portrays moments of hardship and hope in the lives of refugees that Brown himself encountered in three Greek refugee camps in Ritsona, Thessaloniki, and Leros.

Refugee stories today represent an important forum for discussion that can combine volunteer reportage, multi-stakeholder journalistic collaborations, and first-person narration by the story's protagonists. Comics about

and by migrants, occupying a large portion of webcomics and graphic novels, incorporate viewpoints of refugees, artists, volunteers, or journalists working on the ground in displaced communities, war zones, and along the migrant journey. Sometimes some comics are created in collaboration with human rights organizations, especially when the issues addressed are often tragic, complex, and difficult to portray. Unlike what I have framed in GM, comics about migrants are often drawn by Western artists who have collected testimonies directly from migrants or those who have worked with them. At this point, questions may be raised about the legitimacy of Western cartoonists to render migrants' stories appropriately. Scholar Candida Rifkind, within her *Documenting Trauma in Comics: Traumatic Pasts, Embodied Histories, and Graphic Reportage* (2020), addresses precisely the ethical question of what it means to tell a story and who has the right or responsibility to do so. In particular, open questions remain about power issues embedded in how these texts are produced.

Undoubtedly, retelling these stories can increase the Western society's awareness and sensitivity toward the realities of refugees and expand the dominant visual portrayal of contemporary globalization. Comic strips provide access to scenes that are not usually seen in print. Thought balloons, as used in GM, also help to visualize the unspoken and verbal expressions, particularly when the subject is trapped in traumatic memories during everyday activities. Frame by frame, their sequential images reconstruct difficult experiences and harrowing journeys that readers witness.

If comics can act as social and cultural mediators that can facilitate critical thinking, the profession of the cartoonist/protagonist becomes one with a clear social underpinning and a political responsibility.

4. ECO-COMICS: USING IMAGES TO DESCRIBE CLIMATE CHANGE

This section focuses on the role that comics can play in one of the major crises of our generation: climate change. Climate change is defined by the United Nations as any alteration of the global atmosphere that is directly or indirectly attributable to human action. The topic of climate change is complex, and the causes are heterogeneous; all narratives have in common the dramatic consequences spilling over into our daily lives. Public and subjective perceptions on the topic of climate change often revolve around factors such as individual bad habits, diverse socioeconomic demographics, political agendas, and the propagation of certain ideologies, personal relevance attributed to the topic (Arıkan & Günay, 2021), and

the socio-cultural context of reference (Luo & Zhao, 2019). It is added that statistics and policy debates often do not always provide linear and collective guidance, promoting a different view of the phenomenon and a disharmonious "call-for-action." In addition to this, the effects of climate change are time-dilated, and even if we radically changed our habits today by stopping emissions, the consequences would remain the same for decades to come.

Within these discussions, comic books are increasingly recognized as artistic media that can communicate climate change research. Visual narratives can offer readers a new vision of climate change that can reinforce thoughts and actions about the phenomenon. Being a global problem, all stakeholders find, according to some authors (Bach et al., 2018; Doyle, 2020), in comics an easy guide to understanding various notions. In essence, comics create more engaging and persuasive narratives, often based on true stories that combine data with the speculative design of fiction (Dunne & Raby, 2013).

Among the major publications, I mention *Le monde sans fin*, which was the best-selling comic book in French bookstores in 2022. Written by climate and energy engineer Jean-Marc Jancovici and drawn by cartoonist Christopher Blain, the work is about the climate changes our planet is experiencing, the consequences for the present, and what might happen in the future. The wry, biting style presents the phenomenon of pollution through forays of scientific data into everyday activities.

In keeping with the phenomenon's complexity, comics on climate change often combine different perspectives: economic, biological, historical, political, scientific, and even social. Often the focus is also on different actors, as in the case of Mark Kurlansky's *World without Fish*, published in 2011 and designed for an audience of young readers. In this case, the protagonists of the consequences produced by climate change are not just humans but fish, including tuna, salmon, cod, and swordfish, that could disappear within 50 years. The author focuses on a central issue for climate change theorists: the domino effect. The oceans would fill with jellyfish; then seabirds would disappear, then reptiles, then mammals.

The particularity pointed out by many authors (Sou, 2022; Wang, Corner, Chapman, & Markowitz, 2018) is that the very concept of climate change defies the dominant interpretive schemes since it is configured as a set of often intangible elements that we do not perceive in our daily lives. This concealment is especially true for some parts of the world where we try as much as possible to conceal the signs and extent of our actions; power plants are kept at a comfortable distance from major cities, garbage is discreetly picked up and quickly removed from our doorstep, etc.

Comics, with their graphic configurations, are able to make the invisible visible, so abstract data, for example, on global temperature trends, take on body and color, depicting real effects on, for example, forest fires, desertification, wildfires, drought, and pollution. The tables can compress time and space by making explicit connections between causes and effects – just like a scientific diagram. Indeed, a linear narrative could not effectively depict the multi-scalar temporalities of climate change. In contrast, comics allow us to manipulate time; panels can make us do temporal somersaults from one second to the next and give us the active power to define the plot (remember the closure of the first chapter!). These leaps that capture a single fragment now propel us forward decades – forcing the reader into deep reflection and analysis of the experiences being told. Comics can also collapse or mash together different moments in time (Barnes, 2009) with panels spanning entire centuries, for example, jumping from the Industrial Revolution to the impacts of climate change in just a few panels, allowing you to cover a lot of ground.

However, comics can also depict alternative scenarios and present different images that go beyond apocalyptic imagery to inform debates about geographies of hope in relation to climate change (Sou, 2022).

International climate treaties present worrying scenarios in which problems will only intensify in the coming decades as climate change continues unabated. As a result, environmental disasters will be felt most acutely by younger generations, who are also the most mobilized on the issue. By blending images and text, climate change comics seek to educate young people about pressing environmental issues, inspiring them to engage critically and politically with these challenges. Not surprisingly, the protagonists of these comics are precisely young people who engage in activism and suggest ways in which readers can help address environmental problems in their communities. A valuable source to draw from is the *Environmental Comics Database*, which catalogs many environmental comics for children and young adults, graphic novels, and zines that address various environmental issues, from well-known crises, such as climate change, to lesser-known issues, such as algal blooms. These texts demonstrate once again how comics can serve as powerful communicative and pedagogical vehicles.

Despite being an issue experienced globally, the environmental crisis is only partially democratic since the main consequences will particularly impact vulnerable people from communities of color, indigenous communities, poor communities, and other marginalized groups (Sou, 2022). Thus, ethical questions are raised about those often excluded from dominant narratives, with many authors responding to these injustices by creating comics

about populations often relegated to the sidelines. Most often, the image-based narrative on climate change depicts stories of scientists (Leon & Erviti, 2013), public figures, and protesters (O'Neill et al., 2013), and only limited output depicts stories of everyday life.

Collaborating with other colleagues, scholar and activist Gemma Sou published the *Everyday Stories of Climate Change* (2022) to chronicle how families live and adapt to climate change in Bangladesh, South Africa, Bolivia, Puerto Rico, and Barbuda. Fig. 4.4 shows how the effects of climate change also spill over into food prices and how new temperatures take several communities by surprise.

Stories of people with "ordinary" histories are still few (Duan, Zwickle, & Takahashi, 2017; Rebich-Hespanha et al., 2014), and when they do appear, they are often in the background or depicted as victims of climate change in distant geographic locations (Herrmann, 2017). Therefore, the role of researchers and artists becomes increasingly important in communicating the causes, impacts, and solutions of climate change (Wang et al., 2018), intervening, with the dual channel (visual, verbal), on the reader's understanding and awareness (Doyle, 2020). Still, "bottom-up" production (Peterle, 2021) remains limited, so the researcher is tasked to create compelling worlds in climate change communication to engage a wider audience (Corner, Webster, & Teriete, 2015).

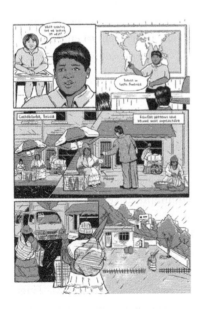 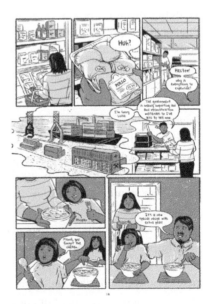

Fig. 4.4. The Everyday Stories of Climate Change.

5. WOMEN AND GENDER IN COMICS

In this chapter, I focused on the political and esthetic role that comics can play in specific social issues. In addition to acting as a medium of testimony, comics can be understood as a vehicle of memory and remembrance, to use the words of cartoonist Chris Ware. The richness of the plot, the narrative fragmented into many panels, becomes a metaphor for real life and its socio-cultural scenarios. This section is devoted to gender and its representations within comics production, which, as we have seen, has long been dominated by men (with specific characteristics, of a specific racial background, with a specific sexual orientation). In recent decades, the comics scene has been supplemented by narrative worlds described by women, gays, lesbians, and transgender people who have taken on different themes (from gender violence to sexual transition) to challenge a patriarchal and heteronormal status quo.

The comic book scene turned out to be dominated by men not only in production but also in the protagonists of the stories. In 1941, All-Star Comics #8 introduced the first female superheroine in history: Wonder Woman. Despite sharing the media stage with bulky colleagues (from Superman to Batman), Wonder Woman is a powerful leader with great strength and speed who keeps pace with the great heroes of the time. The cultural narratives of comic books parallel the social context of reference. Exactly 20 years after the first female character, in 1961, a woman joins the initial lineup of a superhero team – a prestigious status in the comic book world – Sue Storm joins the Fantastic Four. Her superpower was invisibility, which is rather ironic when we consider how much this stylistic choice reflected the social norms of the 1960s, marked mainly by gender disparity in pay, poor advancement opportunities for women, and sexual harassment.

It is not surprising then that it would be women to bring other women's stories to the comics scene, showing vulnerability and sexuality repressed by the social context but virtually the same, independence, autonomy, and social resistance to the patterns of the time. These are the so-called *Graphic Women* described by Chute (2010) who use visual modeling devices to inscribe themselves on the comics scene as "legible, visually drawn" bodies, able to embody at the same time the individual and collective experience of the Second Sex (De Beauvoir, 1949). We have mentioned some female comics artists in Chapter 1; let me expand on this topic. In 1970, the first all-female comic strip was published, entitled *It Ain't Me, Babe* (as the famous Bob Dylan song), co-produced by Trina Robbins and Barbara "Willy" Mendes. It was so successful that two years later, other female authors – Sharon Rudahl, Terry Richards, Lee Marrs, Pat Moodian, Aline Kominsky, and

Trina Robbins – were brought on board to create the first continuous comic strip drawn exclusively by women, Wimmen's Comix (1972–1992).

Looking beyond the United States, beginning in the 1980s, feminist collectives and subsequent comics production began to strengthen in France as well, where several female authors, such as Florence Cestac, Nicole Claveloux, and Jeanne Puchol, to name a few, began publishing militant and feminist bandes dessinée. Specifically, the graphic productions of these women condemned the chauvinism and macho attitudes that had always characterized both the comics industry and the content presented. In essence, comics become a potent visual medium to promote gender struggle (Mulvey, 1989), which seeks to undermine the dominant patriarchal system that views women as objects of vision.

Comics can expose stories of female victimization, as in the case of Latin American women cartoonists who, in the 1980s, began to question media representations, especially in a militaristic climate. For example, Patricia Breccia, with her feminist strip, *Sol de noche*, portrays in stark and harsh detail the difficulties that independent and determined female characters face in a Buenos Aires suffocated by military tyranny (1976–1983) and a macho hegemony. Maitena's works also show an ongoing struggle and self-realization in a patriarchal world. Her "historietas" begin to explore complex sexual themes and propose nonbinary specters of gender and sexual identity to readers, questioning the very concept of gender and achieving a turning point in the history of Latin American comics.

Female representation in Japanese manga has also undergone a transformation. From stereotypical portrayals of girls and women with big round eyes, elongated eyelashes, long noses, thin lips, large breasts, and small waists – which undoubtedly embodied the dominant erotic model – there has been a shift to visual narratives of gender stereotype ruptures and nonbinary relationships. This development has also been made possible by the establishment of female mangaka (artists), such as artist Riyoko Ikeda, who illustrates real-life issues such as drug addiction and suicide, as well as homosexual desires and emotional insecurities normally reserved for girls/women in more traditional manga.

In other contexts, such as the Middle East, the feminist push to produce comics that can offer a break from customarily sexist overtones has only recently been found. For instance, Deena Mohamed's recent webcomic, where an independent, brave, hijabi-wearing superheroine, Qahera, defends women victims of male violence, challenges preconceptions about Muslim women in the Middle East and celebrates Muslim women's right to education and personal expression.

Also relatively recent in India is the creation of a feminist protagonist that challenges discriminatory cognitive maps and sexist actions toward women.

One project worth mentioning is the webcomic Priya Shakti (2014), created by Ram Devineni. The story of Priya, a superheroine who is a rape survivor, was created through the testimonies of many female rape survivors. With her power of persuasion, Priya seeks to inspire all people to change, as Fig. 4.5 illustrates.

In addition to appealing to a wide audience by promoting an empathetic narrative of grief, the intent is to deconstruct the blaming of victims of sexual violence, too often experienced by many women held partly or wholly responsible for the incident, as Fig. 4.6.

Priya's story has become a powerful voice in the global women's rights movement and a symbol of solidarity against gender-based violence.

Comics on femicide, rape, domestic violence, sex trafficking, and other forms of violence have been published with increasing intensity in recent years. Representing abuse through the medium of comics is undoubtedly

Fig. 4.5. Priya Shakti.

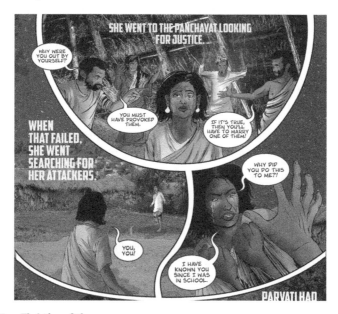

Fig. 4.6. Fighting Stigma.

an approach not without problems since all narratives are characterized as having a solid visual (Groensteen 2008) and, therefore, potentially traumatic impact. This concern has been embraced by the feminist critical theory that seeks to understand how feminist representations can (and should) avoid glamorization and the hypersexualization of sexist abuse (Andrijasevic, 2007; DeKeseredy & Corsianos, 2016; Mandolini, 2021). Narrative responses from women cartoonists around the world have thus sought to challenge the simplistic representation of sexist abuse (Bettaglio, Mandolini, & Ross, 2018) by bringing the debate to bear on the ethical challenges of (re)producing images of violence (Mandolini, 2021).

REFERENCES

Anand, T., Kishore, J., Ingle, G. K., & Grover, S. (2018). Perception about use of comics in medical and nursing education among students in health professions' schools in New Delhi. *Education forHealth (Abingdon), 31*, 125–129.

Andrijasevic, R. (2007). Beautiful dead bodies: Gender, migration and representation in anti-trafficking campaigns. *Feminist Review, 86*(1), 24–44.

Arıkan, G., & Günay, D. (2021). Public attitudes towards climate change: A cross-country analysis. *The British Journal of Politics and International Relations, 23*(1), 158–174. doi:10.1177/1369148120951013

Bach, B., Wang, Z., Farinella, M., Murray-Rust, D., & Henry Riche, N. (2018). Design patterns for data comics. In *Proceedings of the 2018 CHI conference on human factors in computing systems*; ACM, Montreal QC Canada (pp. 1–12).

Barnes, D. (2009). Time in the gutter: Temporal structures in watchmen. *KronoScope, 9*(1–2), 51–60.

Bettaglio, M., Mandolini, N., & Ross, S. (2018). *Rappresentare la violenza di genere. Sguardi femministi tra critica, attivismo e scrittura*. Milan: Mimesis.

Bitz, M. (2010). *When Commas meet Kryptonite: Classroom lessons from the comic book project*. Language and Literacy Series, Teachers College Press.

Butler, J. (2009). *Frames of war: When is life grievable?* London: Verso.

Chute, H. L. (2010). *Graphic women: Life narrative and contemporary comics*. Columbia: Columbia University Press.

Cary, S. (2004). *Going graphic: Comics at work in the multilingual classroom*. Portsmouth. NH: Heinneman.

Corner, A., Webster, R., Teriete, C. (2015). *Climate visuals: Seven principles for visual climate change communication (based on International Social Research)*. Oxford: Climate Outreach.

De Beauvoir, S. (1949). *Le Deuxième Sexe*. Paris: Éditions Gallimard.

De Stefano, A., Rusciano, I., Moretti, V., Scavarda, A., Green, M. J., Wall, S., & Ratti, S. (2023). Graphic medicine meets human anatomy: The potential role of comics in raising whole body donation awareness in Italy and beyond. A pilot study. *Anatomical Sciences Education*, 16(2), 209–223. doi: 10.1002/ase.2232. Epub 2022 Dec 7. PMID: 36346170.

DeKeseredy, W. S., & Corsianos, M. (2016). *Violence against women in pornography*. London: Routledge.

Doyle, J. (2020). Creative communication approaches to youth climate engagement: Using speculative fiction and participatory play to facilitate young people's multidimensional engagement with climate change. *International Journal of Communication*, 14(2020), 2749–2772.

Duan, R., Zwickle, A., & Takahashi, B. (2017). A construal-level perspective of climate change images in US newspapers. *Climatic Change*, 142(3–4), 345–360.

Duncan, R., & Smith, R. J. (2009). *The power of comics: History, form and culture*. New York: Continuum.

Dunne, A., & Raby, F. (2013). *Speculative everything: Design, fiction, and social dreaming*. Cambridge, MA: The MIT Press.

Gariglio, L. (2010). The visual studies and the use of photography in ethnographic and sociological research. *Rassegna Italiana di Sociologia*, 117–140.

Girotti, C. (2016). *La medicina grafica nell'educazione e nella cura della persona, Biografie dell'esistenza*. Saggi-Essays.

Green, M. J. (2013). Teaching with comics: A course for fourth-year medical students. *Journal of Medical Humanities*, 34, 471–476.

Green, M. J. (2015). Comics and medicine: Peering into the process of professional identity formation. *Academic Medicine*, 90(6), 774–779.

Green, M. J., & Myers, K. R. (2010). Graphic medicine: Use of comics in medical education and patient care. *BMJ: British Medical Journal*, 340(7746) (March), 574–577.

Groensteen, T. (2008). Why are comics still in search of cultural legitimization. In J. Heer & K. Wo (Eds.), *A comics studies reader*. (pp. 3–12). Jackson, MO: University Press of Mississippi.

Hansen, B. (2004). Medical history for the masses: How American comic books celebrated heroes of medicine in the 1940s. *Bulletin of the History of Medicine*, 78, 148e91.

Hatem, D. S., & Ferrara, E. (2001). Becoming a doctor: Fostering humane caregivers through creative writing. *Patient Education and Counseling*, 45(1), 13–22.

Herrmann, V. (2017). America's first climate change refugees. *Energy Research and Social Science*, 31, 205–214.

Hescher, A. (2016). *Reading graphic novels: Genre and narration.* Berlin: Walter de Gruyter.

Hoffman, A. (2021). Comics and medicine: Using graphic narratives in pharmacy education. *American Journal of Pharmaceutical Education*, 21, 8797.

Hutchinson, K. (1949). An experiment in the use of comics as instructional material. *Journal of Educational Sociology*, 23, 236–245.

Jauss, H. R. (1982). Toward an *aesthetic of reception, theory and history of literature* (Vol. 2). Minneapolis: University of Minnesota Press.

Labarre, N. (2020). *Understanding genres in comics.* Cham: Palgrave Macmillan.

Leon, B., & Erviti, M. C. (2013). Science in pictures. *Public Understanding of Science*, 24(2), 183–199.

Luo, Y., & Zhao, J. (2019). Motivated attention in climate change perception and action. *Frontiers in Psychology*, 10, 1541.

Maatman, T. C., Minshew, L. M., & Braun, M. T. (2022). Increase in sharing of stressful situations by medical trainees through drawing comics. *Journal of Medical Humanities*, 43, 467–473.

Mandolini, N. (2021). Un fumetto per la Convenzione d'Istanbul: SHERO. Intervista con Alice Degl'Innocenti (rete D.I.Re.). *Sketchthatstory.com*. Retrieved from https://www.sketchthatstory.com/post/un-fumetto-per-la-convenzione-di-istanbul-shero-intervista-con-alice-degl-innocenti-rete-d-i-re. Accessed on August 24, 2022.

Manohar, S. (2022). Web exclusive. Annals graphic medicine – No access: Barriers for people with disabilities. *Annals of Internal Medicine*, 175, W29–W30.

Mark, M. (2011). *The Colonial Heritage of French Comics*. Liverpool: Liverpool University Press.

McKinney, M. (2021). *Postcolonialism and migration in French Comics*. Leuven: Universitaire Pers Leuven.

Mirza, S. (2021). Annals graphic medicine – A differing perspective. *Annals of Internal Medicine, 174*.

Monrouxe, L. V., Rees, C. E., & Hu, W. (2011). Differences in medical students' explicit discourses of professionalism: Acting, representing, becoming. *Medical Education, 45*(6), 585–602.

Moretti, V., & Scavarda, A. (2021). Graphic medicine. *Una disciplina in cerca d'autore. Rassegna Italiana di Sociologia, 3*, 733–754.

Moretti, V., Scavarda, A., & Ratti, S. (2023). Il fumetto nella formazione medica. Il caso della Scuola di Medicina e Chirurgia di Bologna. *Salute e Società, XXII 2, 129*, 139.

Mulvey, L. (1989). Visual pleasure and narrative cinema. In L. Mulvey (Ed.), *Visual and other pleasures* (pp. 14–26). Bloomington, IN: Indiana University Press.

Nabizadeh, G. (2019). *Representation and memory in graphic novels* (208 pp.). London: Routledge.

O'Neill, S. J., Boykoff, M., Niemeyer, S., & Day, S. A. (2013). On the use of imagery for climate change engagement. *Global Environ- mental Change: Human and Policy Dimensions, 23*(2), 413–421.

Ousager, J., & Johannessen, H. (2010). Humanities in undergraduate medical education: A literature review. *Academic Medicine, 85*(6), 988–998.

Peterle, G. (2021). *Comics as a research practice*. London: Routledge.

Phelan, J. (2008). *Narrative as rhetoric*. Columbus, OH: Ohio State University Press.

Ravelo, L. C. (2013). The use of comic strips as a means of teaching history in the EFL class: Proposal of activities based on two historical comic strips adhering to the principles of CLIL. *Latin American Journal of Content & Language Integrated Learning, 6*(1), 1–19.

Rebich-Hespanha, S., Rice, R. E., Montello, D. R., Retzloff, S., Tien, S., & Hespanha, J. P. (2014). Image themes and frames in US print news stories about climate change. *Environmental Communication, 9*(4), 491–519.

Rifkind, C. (2020). *Documenting trauma in comics*. New York: Springer.

Schuitz, A. (1944). The stranger: An essay in social psychology. *American Journal of Sociology, 49*, 499–507.

Schuitz, A. (1945). The Homecomer. *American Journal of Sociology, 50*(5), 369–376. http://www.jstor.org/stable/2771190

Serrano, N. L. (2021). *Immigrants and comics graphic spaces of remembrance, transaction, and mimesis*. London: Routledge.

Simmel, G. (1908). *Soziologie: Vntersuchungen uber die formen der vergesellschaftung [Sociology: Studies in the forms of societalization)*. Leipzig: Duncker & Humblot.

Sorlin, P. (2001). *Figli di Nadar. Il «secolo» dell'immagine analogica*. Torino: Einaudi.

Sou, G. (2022). Wiley Lecture 2022. Communicating climate change with comics: Life beyond apocalyptic imaginaries. *Geographical Research*, 1–13.

Swanson, J. G. (2016). Web Exclusives. Annals graphic medicine: Atrial flutter. *Annals of Internal Medicine, 164*.

Tsao, P., & Yu, C. H. (2016). "There's no billing code for empathy" – Animated comics remind medical students of empathy: A qualitative study. *BMC Medical Education, 16*, 204.

Vinson, A. H., & Underman, K. (2020). Clinical empathy as emotional labor in medical work. *Social Science & Medicine, 251*, 112904.

Wang, S., Corner, A., Chapman, D., & Markowitz, E. (2018). Public engagement with climate imagery in a changing digital landscape. *Wiley Interdisciplinary Reviews: Climate Change, 9*(2), e509.

Winch, G., Ross Johnston, R., March, P., Ljungdahl, L., & Holliday, M. (2010). *Literacy: Reading and writing and children's literature* (4th ed.). Melbourne: Oxford University Press.

CONCLUSION

Throughout this book, I frequently emphasize the hybrid quality of the medium, which combines images and text. As a result, the experience of engaging with comics can be seen as a hybrid itself, encompassing elements of both reading and observation. The words and visuals in comics work together in a mutual and complementary manner to construct meaning. However, it is essential to note that there are also comics that solely rely on images. In these instances, the reader's interaction primarily involves flipping through the pages and observing the visual content without the explicit use of textual elements. In reality, as pointed out in Chapter 1, images are never something isolated but are articulated in a well-defined sequence. The act of visual engagement in comics, in contrast to forms like painting, entails a distinctive mode of observation that is mediated by specific conventions and guided by the author's deliberate narrative construction. Thus, the act of looking at comics necessitates a nuanced understanding of the medium's established principles and the intentional flow of visuals, shaping the reader's experience and perception. The same attention that is applied to graphics must be given to the written content: each sentence must be carefully selected for the purpose of proper interaction with the drawing. Looking-reading is thus closely integrated.

On the contrary, comics, often appreciated only in the narrative sphere, whether it is offered in the purely entertaining form of the daily strip or in the more elaborate expression of the graphic novel, prove to be a tool capable of conveying complex content in a valid and accessible way. Comics-based can thus be considered a new tool capable of responding adequately to the unprecedented challenges encountered in the study of social phenomena, fitting to what Cardano and Gariglio (2022) refer to as *hybrid* practices of qualitative research.

This work has sought to broaden the contribution of comics and graphic novels to social research and qualitative research by addressing the following – by no means exhaustive – dimensions:

• What are the main steps of comics-based research?

• How can the graphic medium help elicit participants' narratives?

- To what extent can comics be incorporated into traditional social research techniques?

- What are the barriers (theoretical and methodological) that researchers might encounter using comics?

Researchers from different sociological subject areas can use comics to carry out research, teach students, train professionals, and engage the public. There are many examples of graphic sociology across the discipline to learn more about this creative method's relative utility and limitations. However, it is central to be aware that ethical considerations must permeate the research process holistically, especially in biomedical or migrants research. In the proposed methodological reflection, comics cover multiple dimensions. It can be understood as a physical artifact produced by participants or the researcher that supports information construction. The comic strip is also a means of scientific communication, with which to share results and findings, reaching a broad audience of both experts and non-experts on the subject. The comic strip additionally serves as a narrative work rich in meaning and capable of tangibly conveying a number of concepts and expressions crucial to the very formulation of the research.

While, at first glance, comics-based research seems to be tied mainly to Sociology, it also is relevant to a host of other disciplines, including women's studies, environmental studies, disability studies, science and technology studies, critical race studies, queer studies, and animal studies. Hopefully, this book will facilitate international and interdisciplinary collaboration among researchers interested in exploring the utility and limitations of the graphic medium.

A comic is worth a thousand words.

REFERENCE

Cardano, M., & Gariglio, L. (2022). *Metodi qualitativi. Pratiche di ricerca in presenza, a distanza e ibride*. Roma: Carocci.

INDEX

Printed and bound by CPI Group (UK) Ltd, Croydon, CR0 4YY

26/11/2024

14599978-0002